Glacier impressions

photography by John Reddy and Kerry T. Nickou

FARCOUNTRY
PRESS

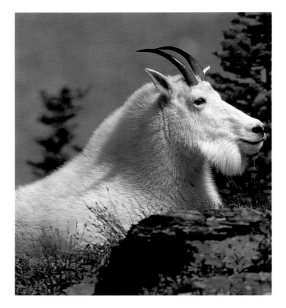

Above: Mountain goat. KERRY T. NICKOU

Right: Beargrass abloom below Mount Oberlin and Mount Cannon. JOHN REDDY

Title page: Spring colors at East Glacier. KERRY T. NICKOU

Front cover: Baring Creek. JOHN REDDY

Back cover: Two Medicine Lake. KERRY T. NICKOU

ISBN 10: 1-56037-205-2
ISBN 13: 978-1-56037-205-9
Photographs © by John Reddy & Kerry T. Nickou as indicated
© 2002 Farcountry Press

For more information on our books write: Farcountry Press, P.O. Box 5630, Helena, MT 59604; call (800) 821-3874; or visit www.farcountrypress.com.

Created, produced, and designed in the United States. Printed in Korea.
14 13 12 11 5 6 7 8

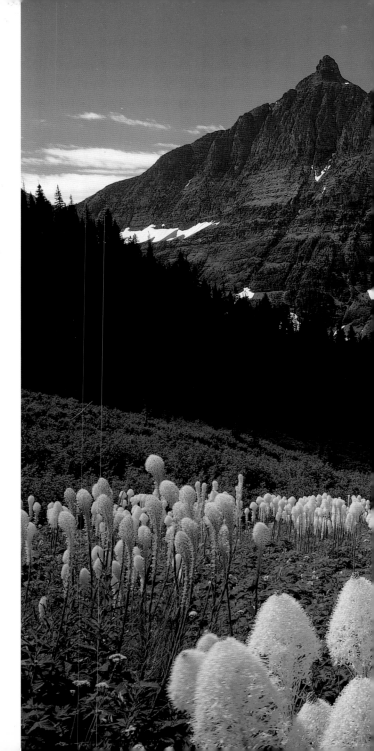

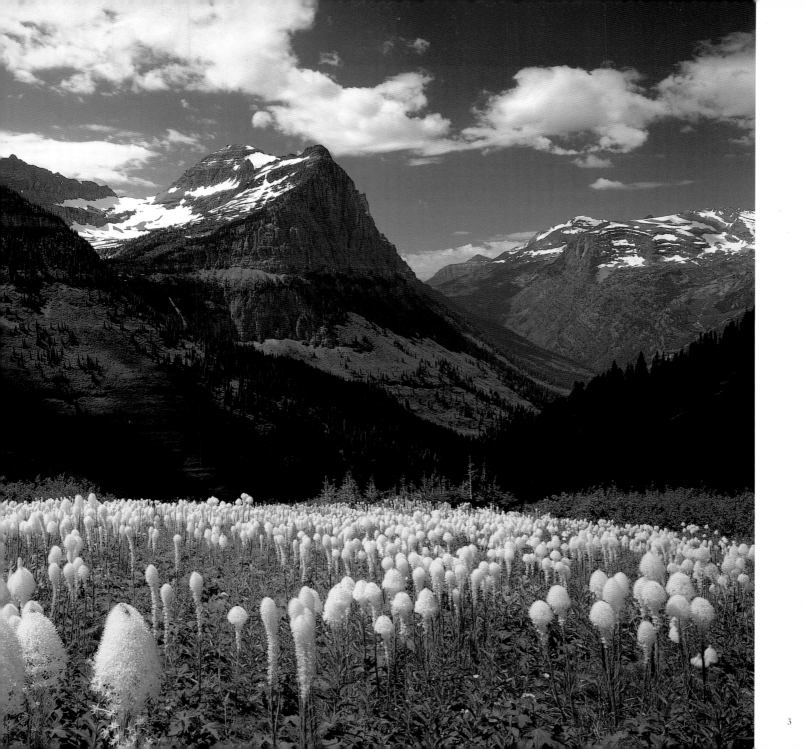

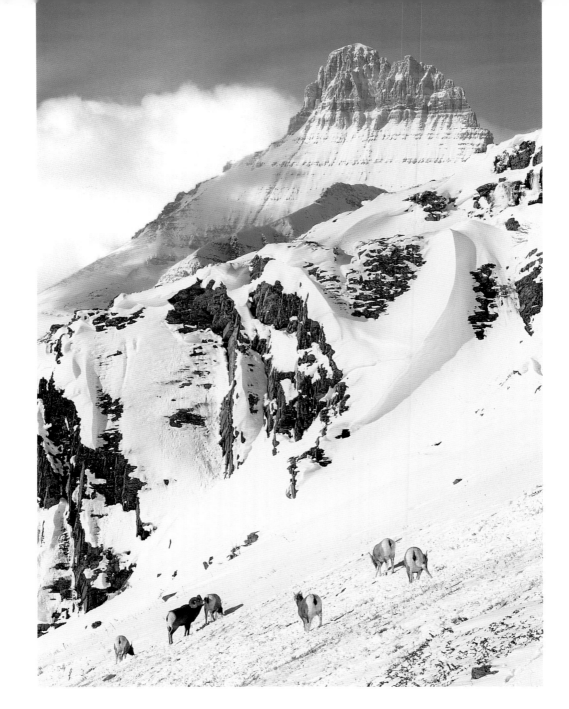

Right: Bighorn sheep at Many Glacier.

KERRY T. NICKOU

Facing page: Lunch Creek Basin.

KERRY T. NICKOU

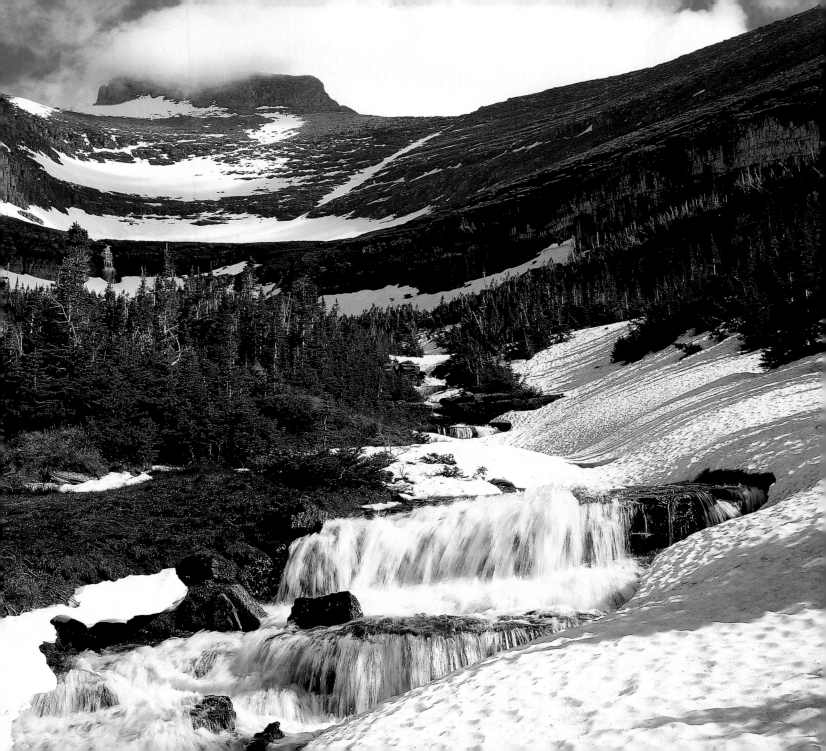

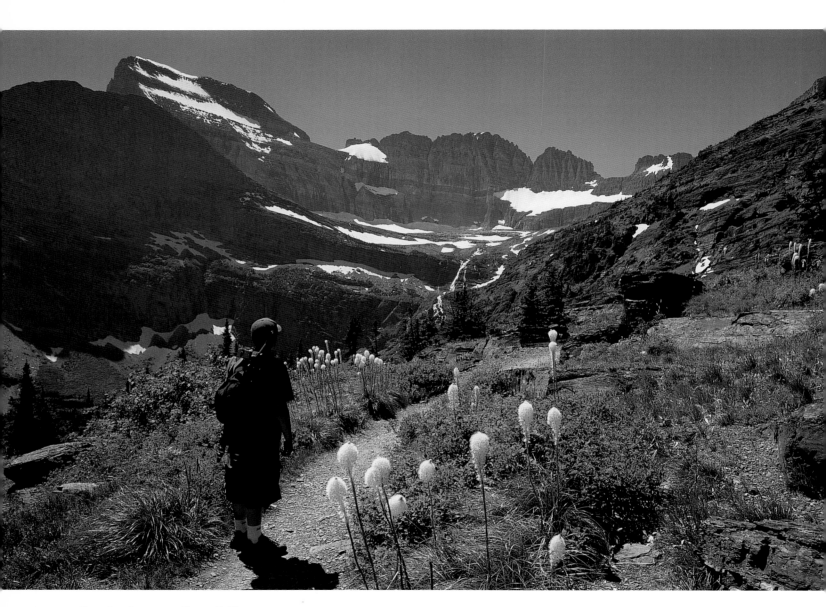

Above: On the way to Grinnell Glacier. JOHN REDDY

Facing page: The long view from Brown's Pass Trail to Bowman Lake. JOHN REDDY

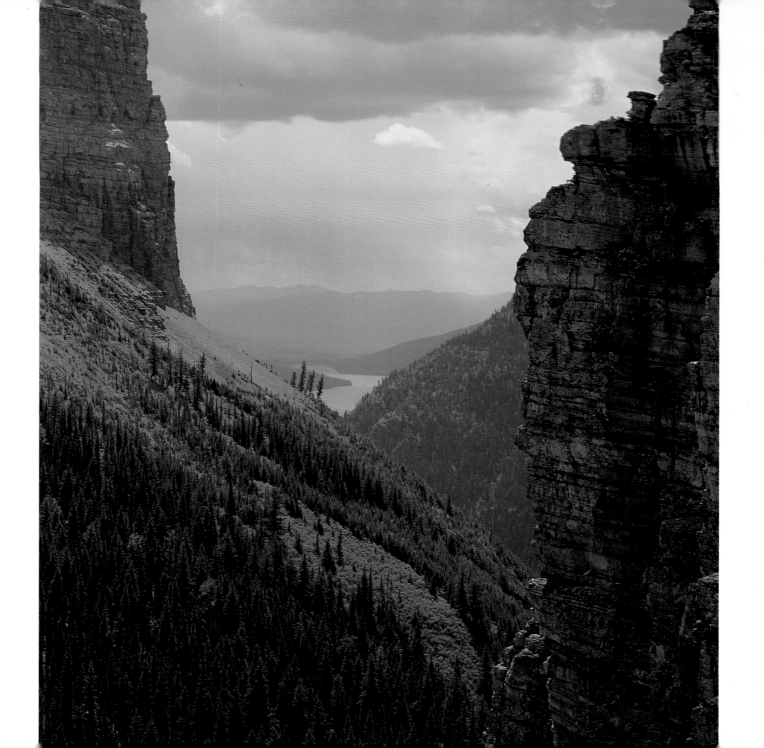

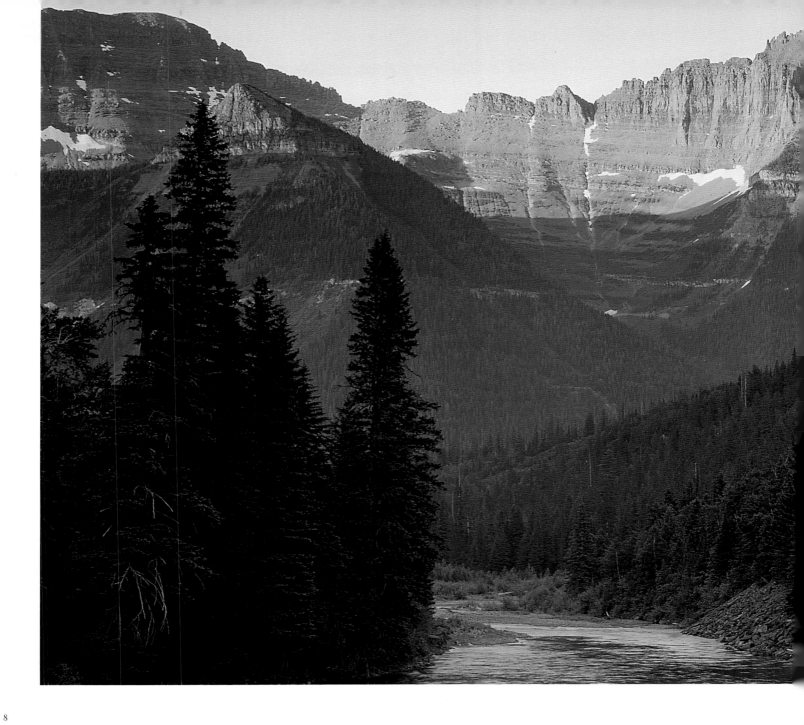

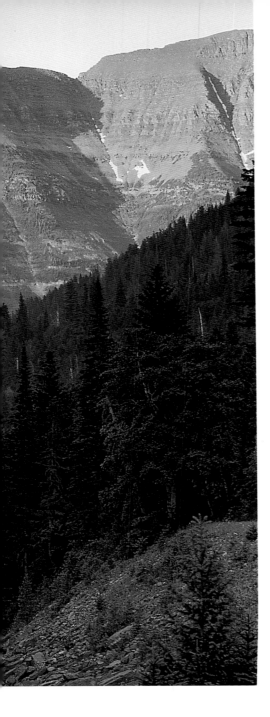

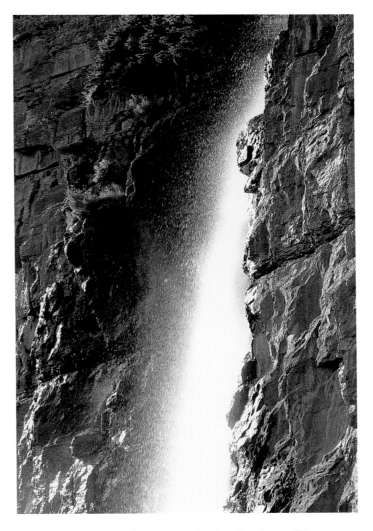

Above: Water flows beside Going-to-the-Sun Road east of Piegan Tunnel. JOHN REDDY

Left: McDonald Creek runs below the Garden Wall. JOHN REDDY

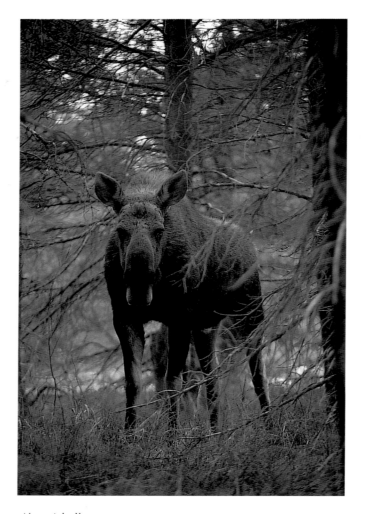

Above: A bull moose. KERRY T. NICKOU

Right: Iceberg Lake Wall. KERRY T. NICKOU

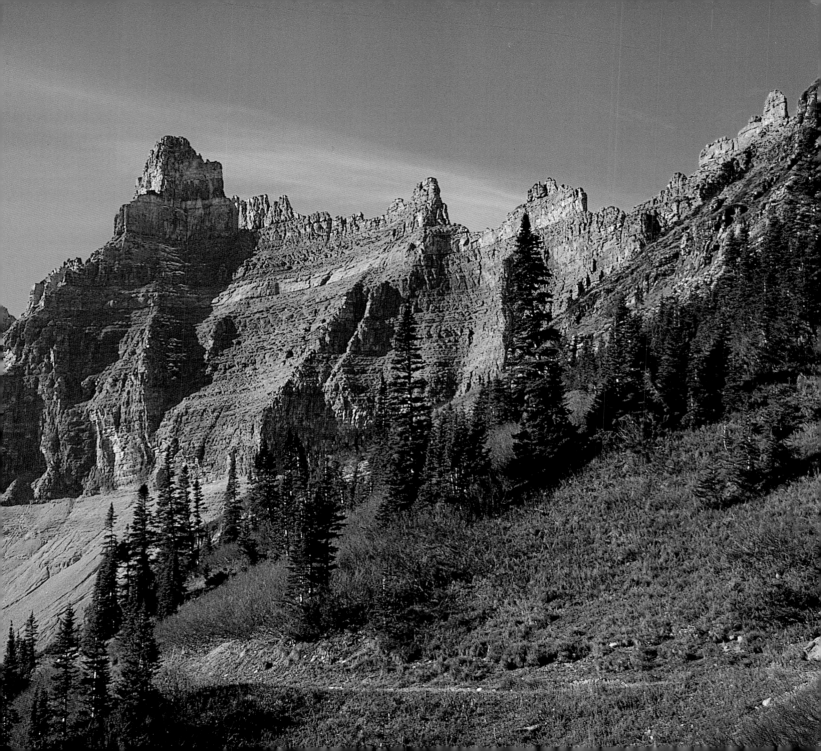

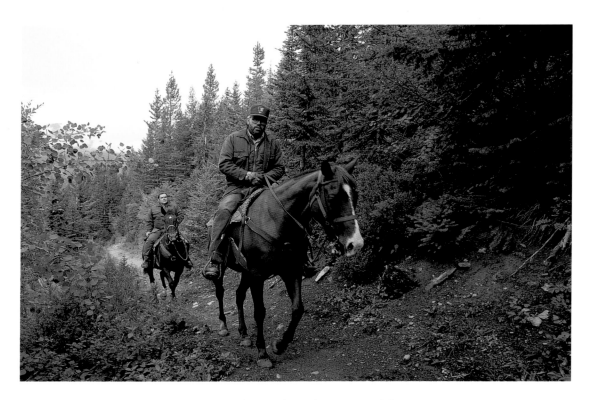

Above: Backcountry rangers travel the park the way the earliest tourists did. JOHN REDDY

Right: Lunch Creek's many cascades are east of Logan Pass. JOHN REDDY

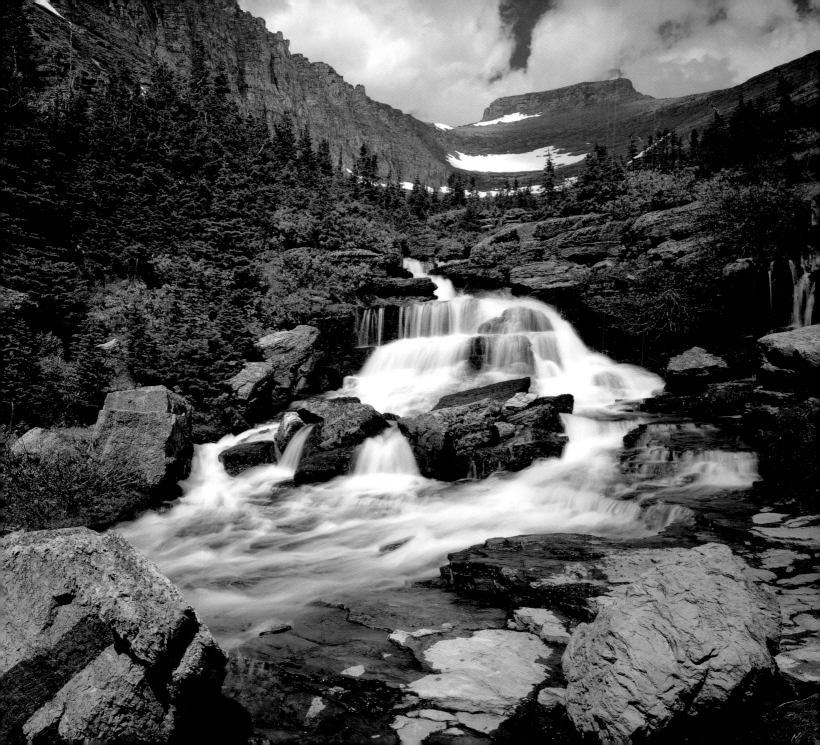

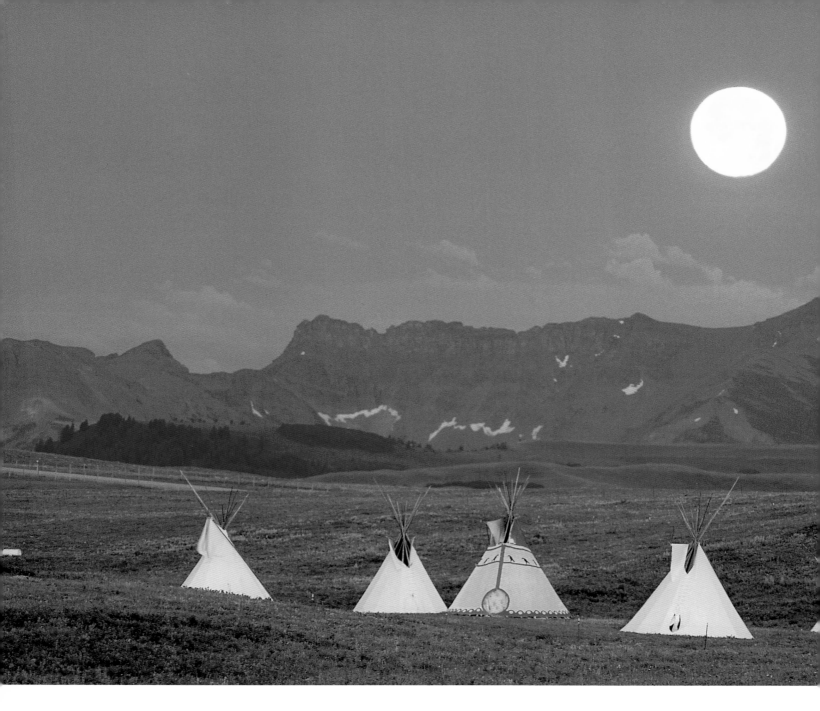

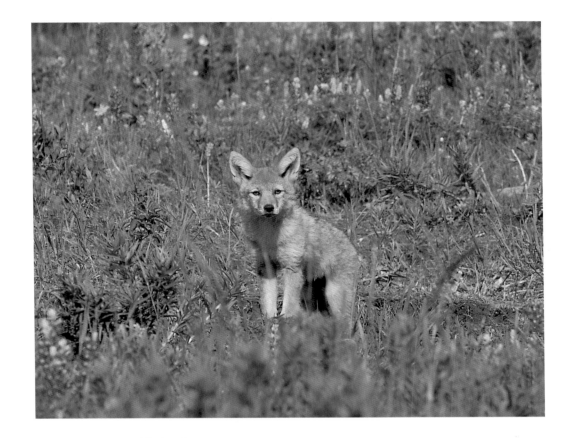

Above: This coyote is filled with curiosity. KERRY T. NICKOU

Left: Lodges at Browning on the Blackfeet Indian Reservation, just east of the park. KERRY T. NICKOU

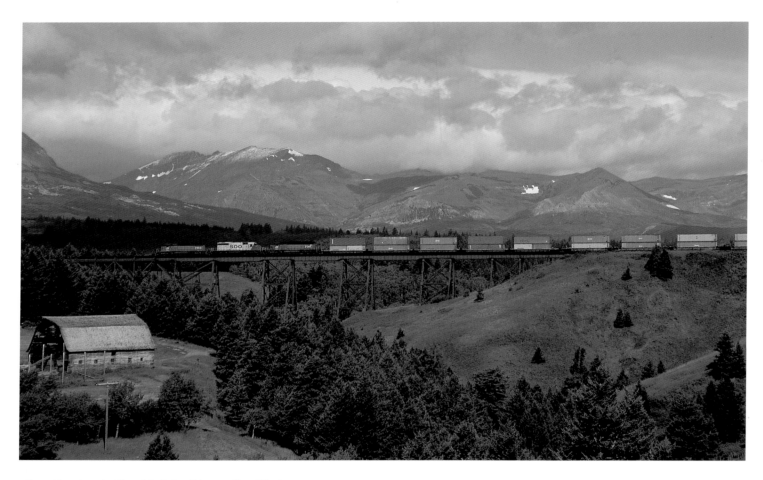

Above: Crossing the Two Medicine River at East Glacier. KERRY T. NICKOU

Facing page: Essex Creek. KERRY T. NICKOU

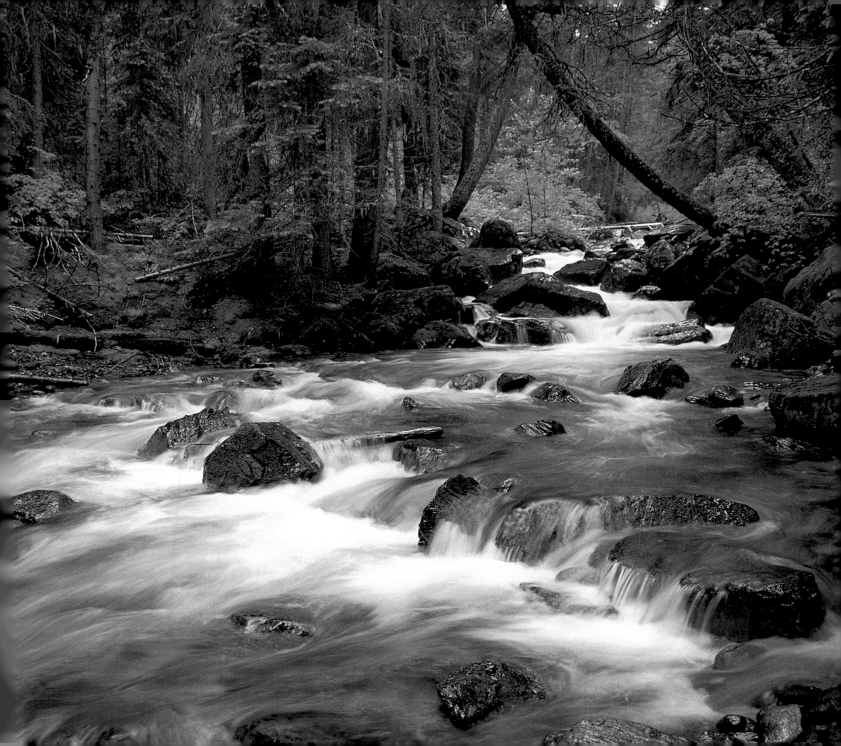

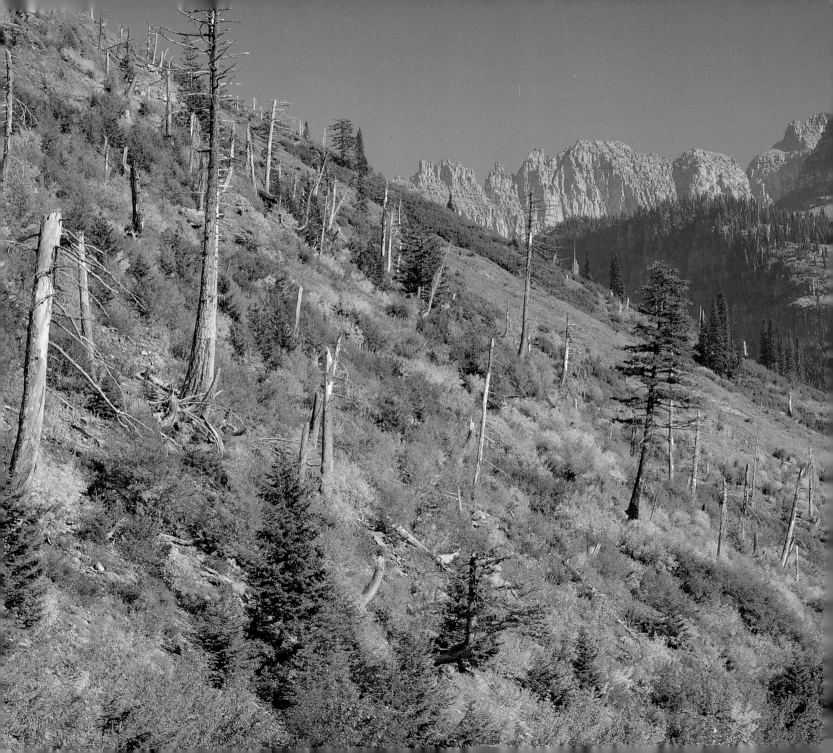

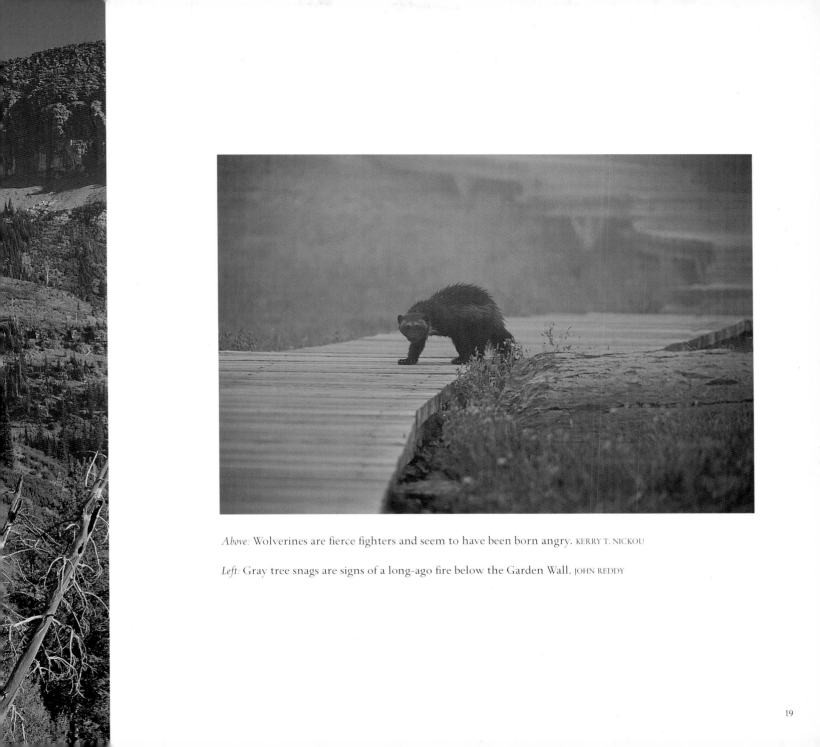

Above: Wolverines are fierce fighters and seem to have been born angry. KERRY T. NICKOU

Left: Gray tree snags are signs of a long-ago fire below the Garden Wall. JOHN REDDY

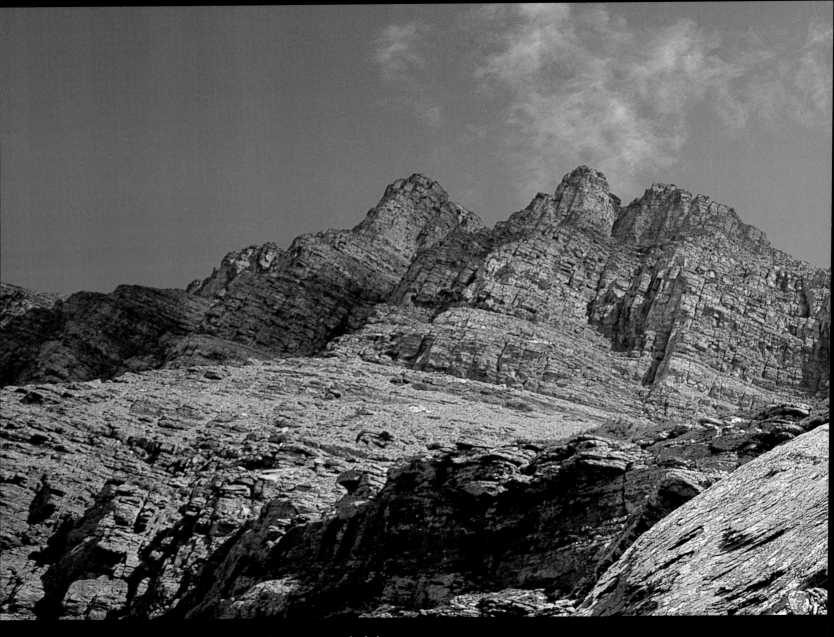

Mountain goats are adept travelers along narrow rocky ledges. JOHN REDDY

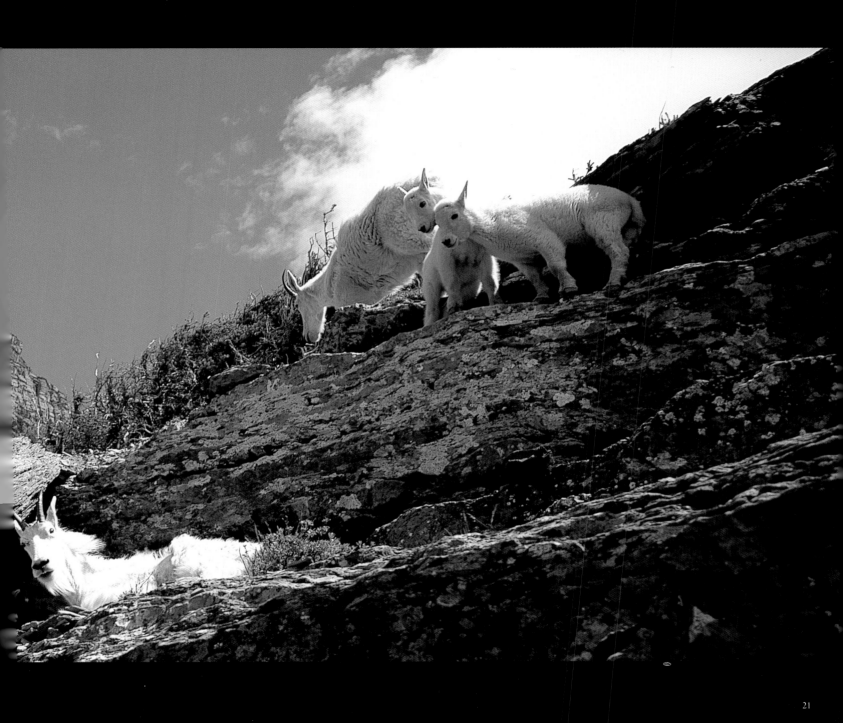

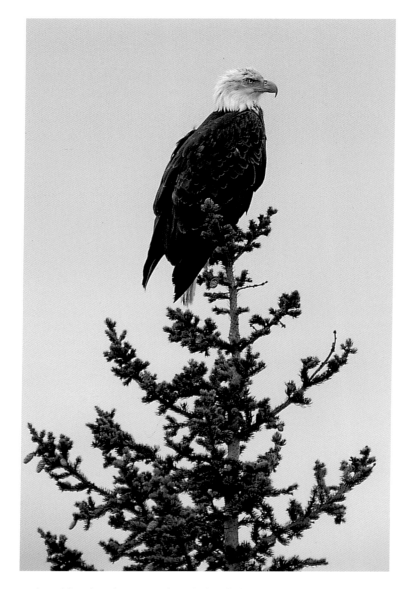

Right: Bald eagles, the national symbol, call the park home. KERRY T. NICKOU

Facing page: Mount Gould. KERRY T. NICKOU

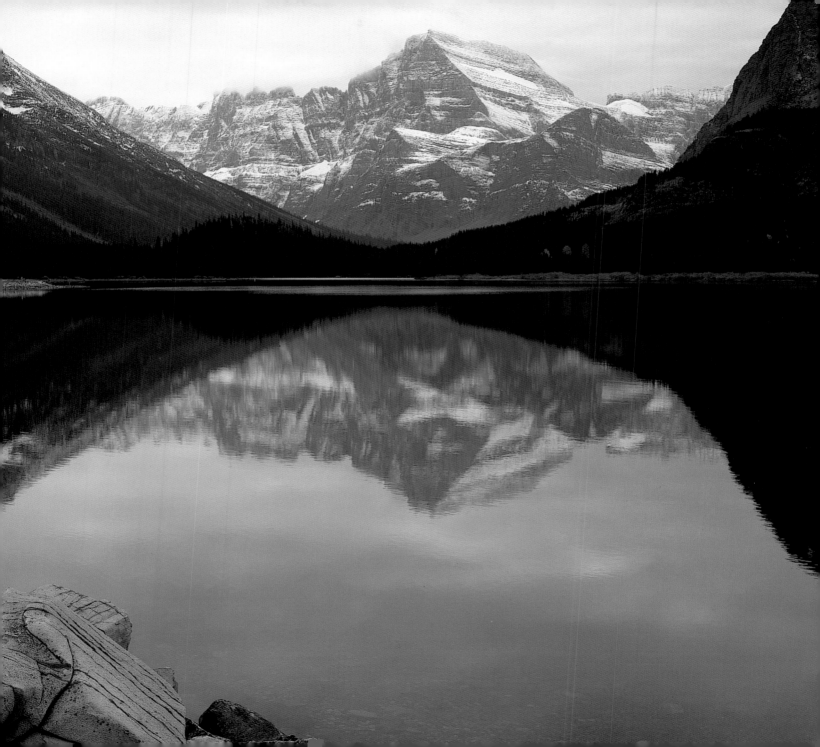

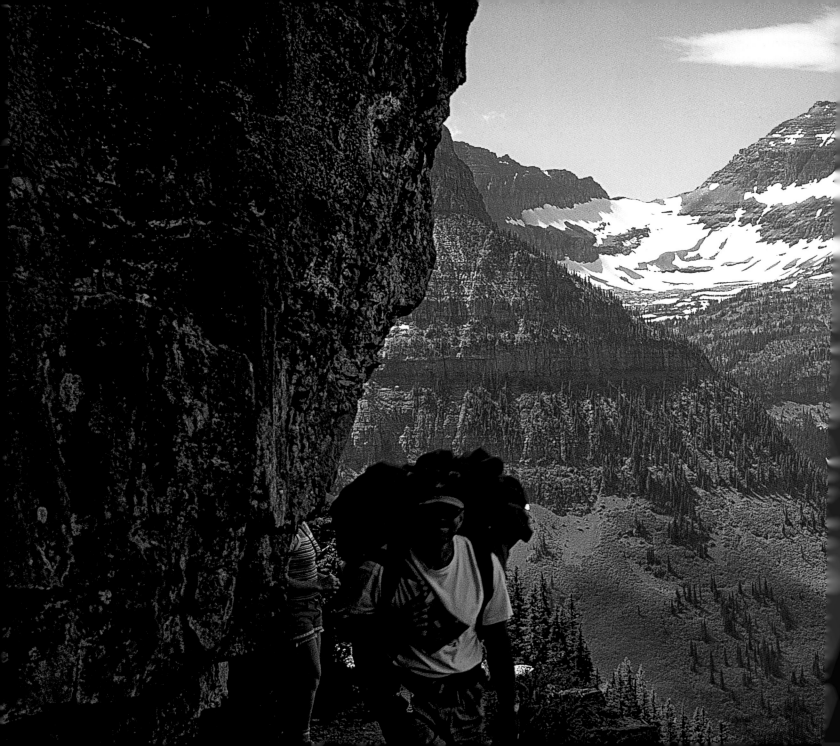

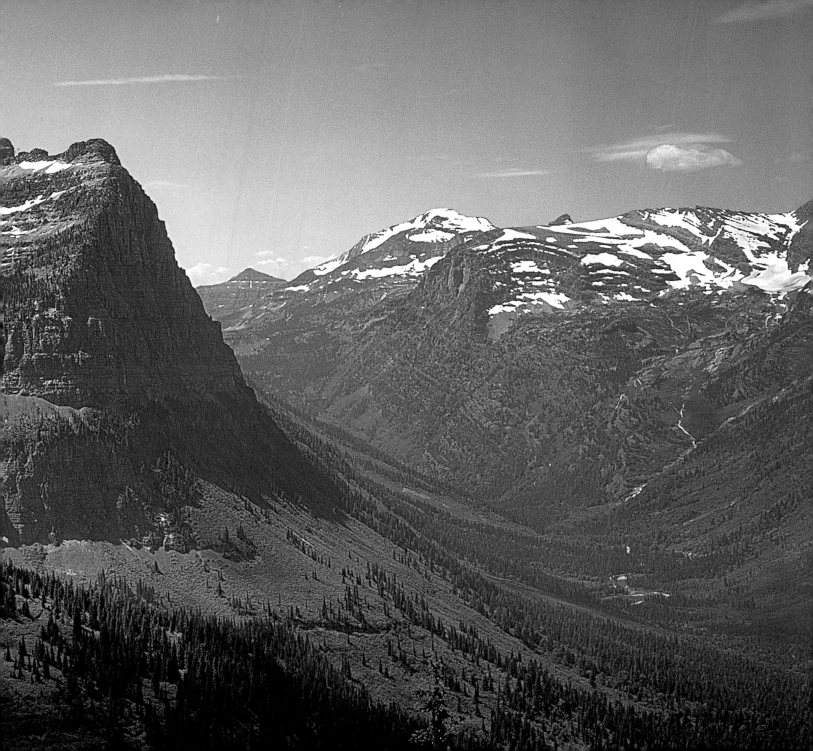

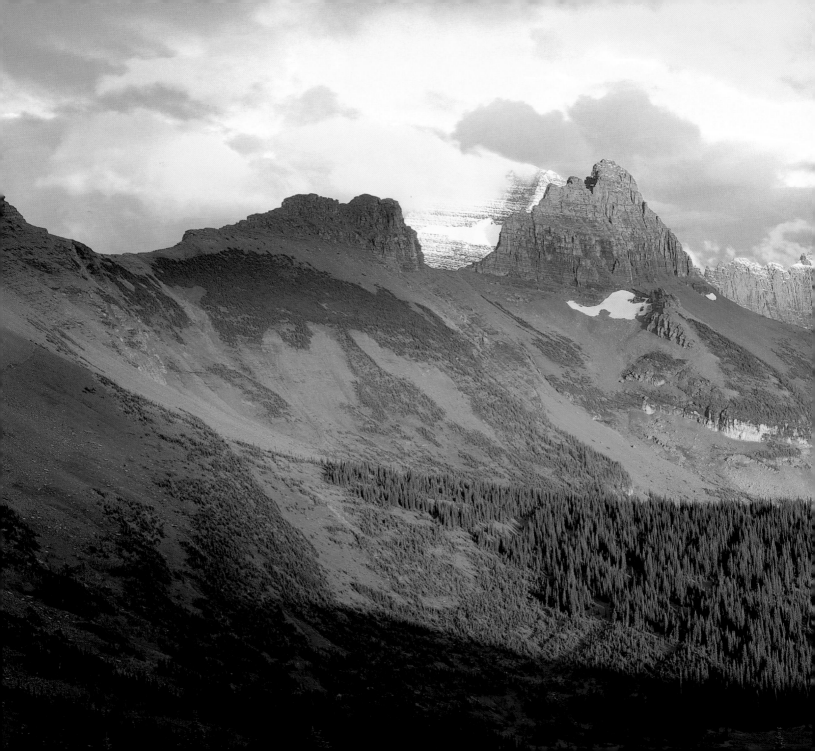

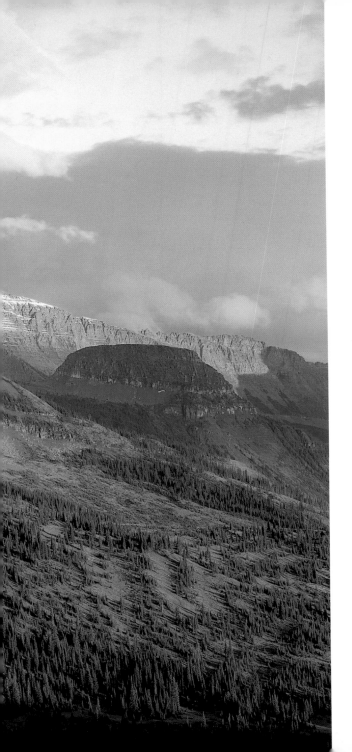

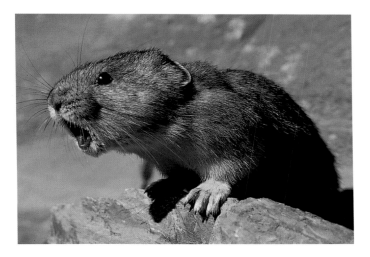

Above: Tiny, scolding pikas let visitors know if they walk too near their homes. KERRY T. NICKOU

Left: Looking to the Garden Wall from Granite Park. JOHN REDDY

Preceding pages: Enjoying the Highline Trail. JOHN REDDY

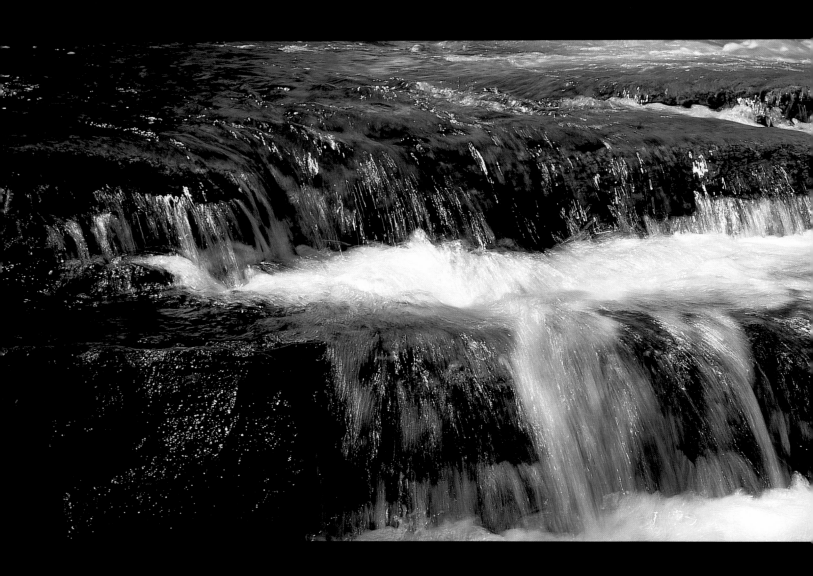

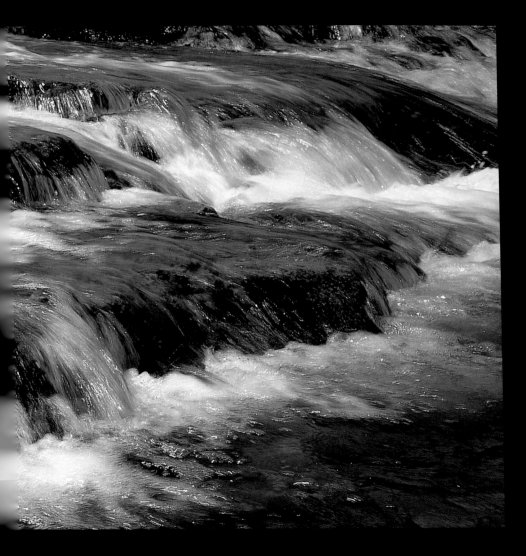

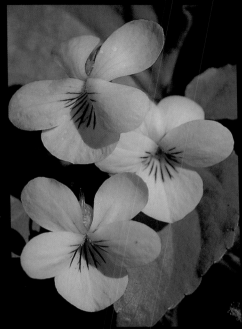

Above: Prairie violets growing near Grinnell Glacier. KERRY T. NICKOU

Left: The aptly named Swiftcurrent Creek. JOHN REDDY

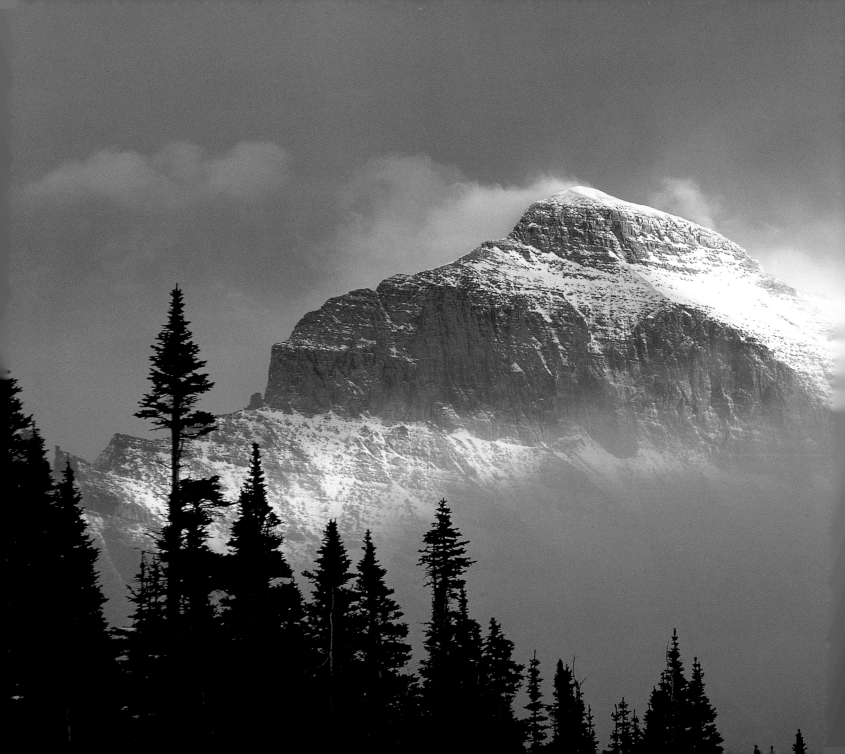

Left: Windy day atop Little Chief Mountain. KERRY T. NICKOU

Below: Long-tailed weasel. KERRY T. NICKOU

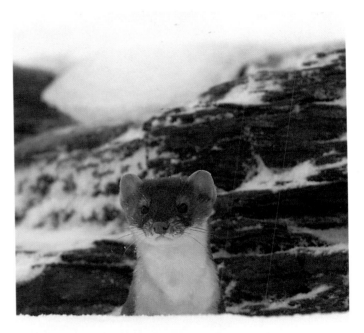

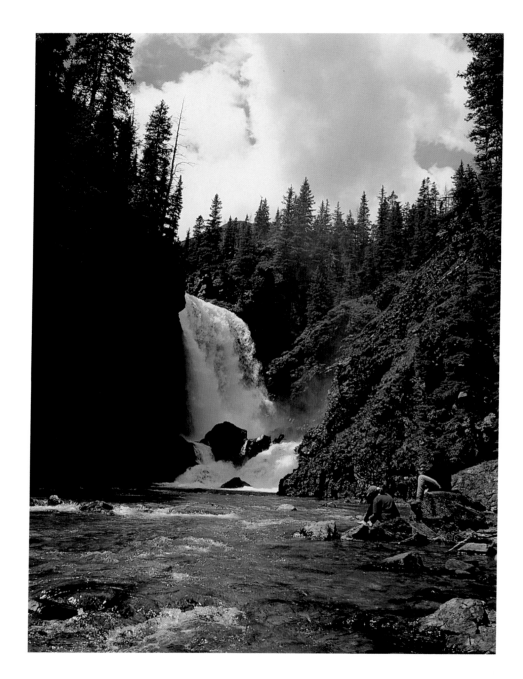

Right: Cooling relief in the Belly River just below Dawn Mist Falls.
KERRY T. NICKOU

Facing page: Sunrise over St. Mary.
KERRY T. NICKOU

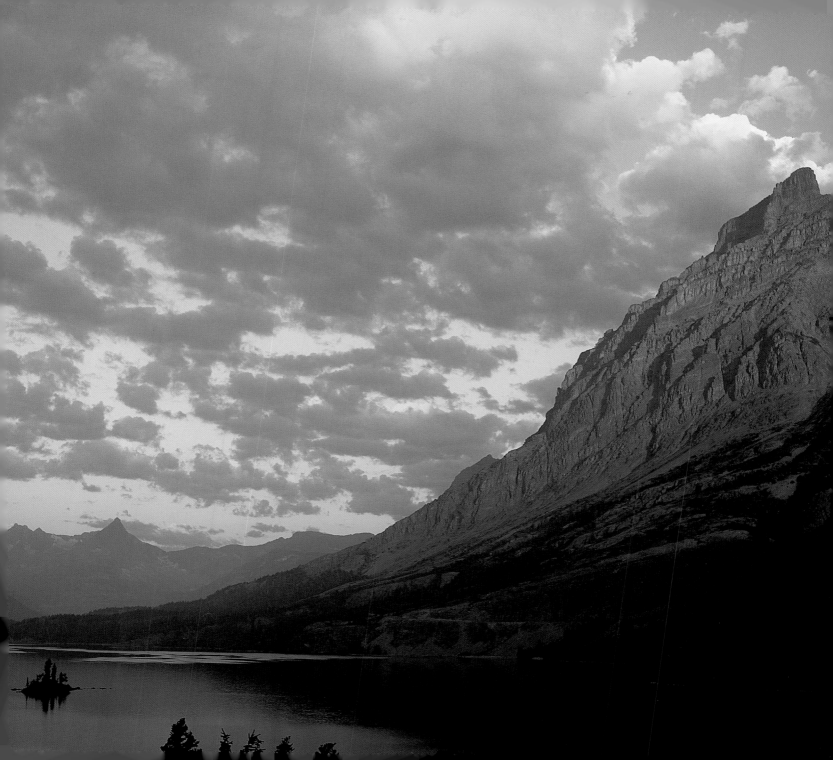

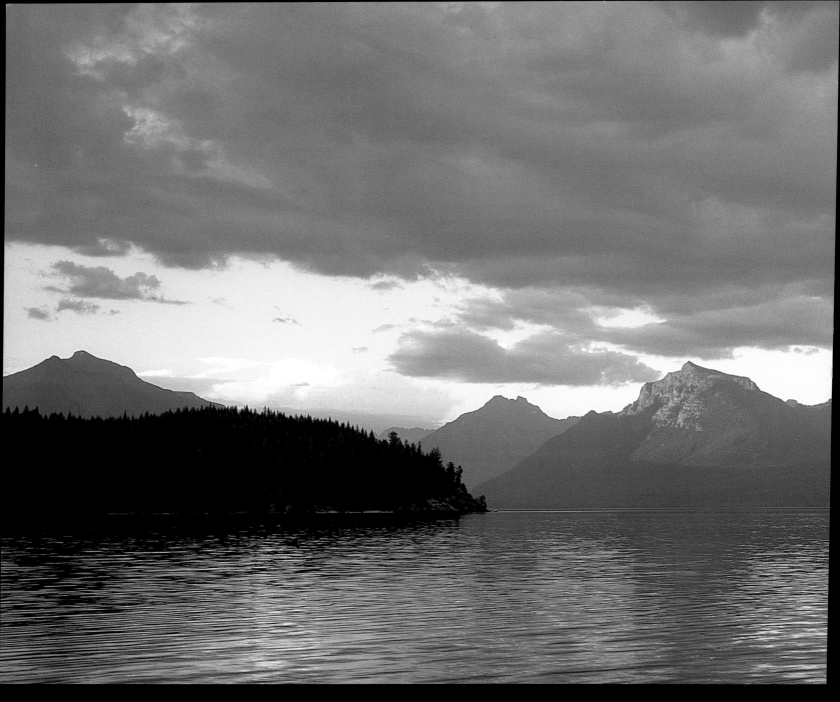

Lake McDonald. JOHN REDDY

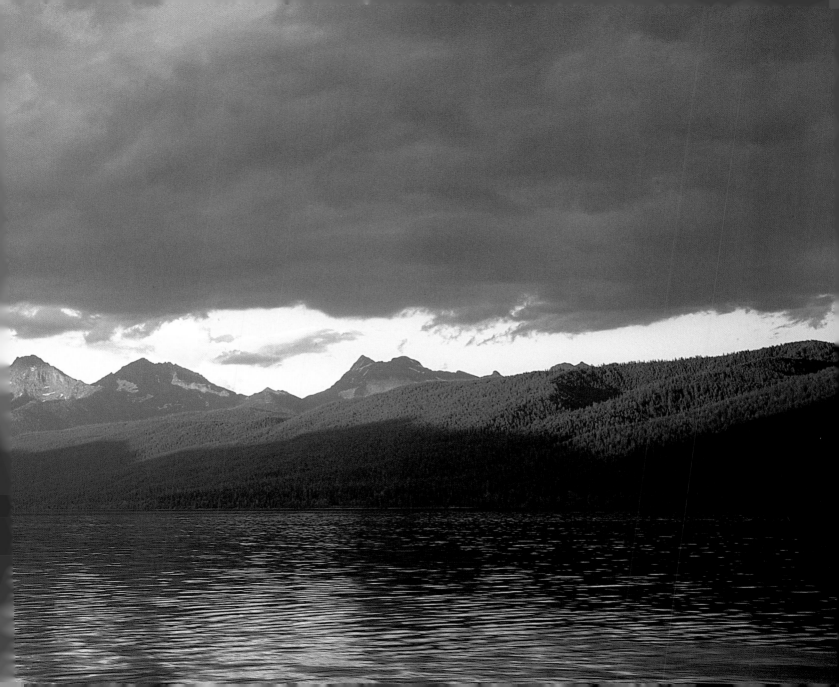

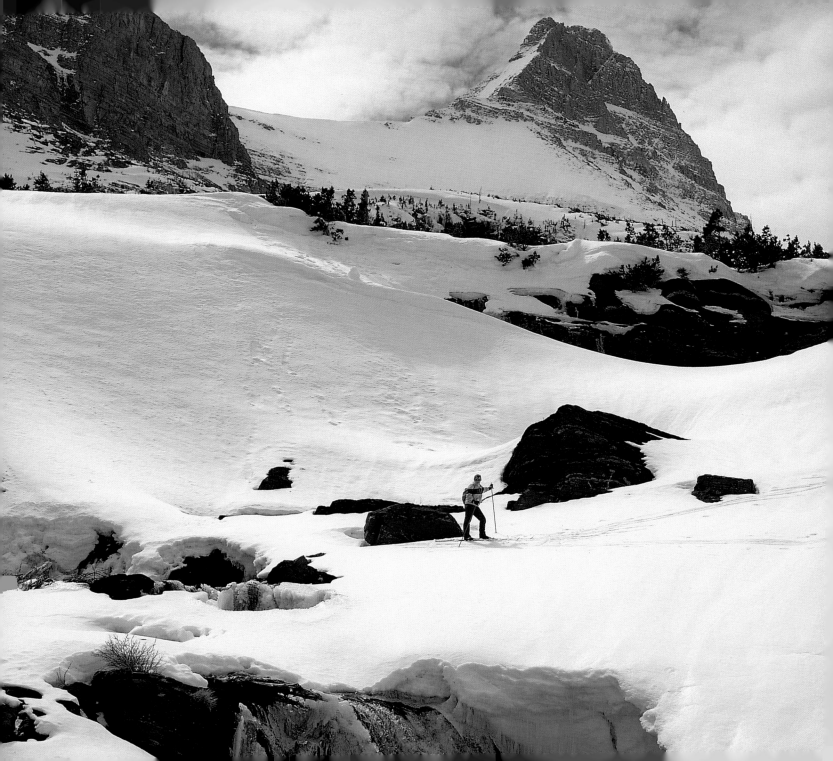

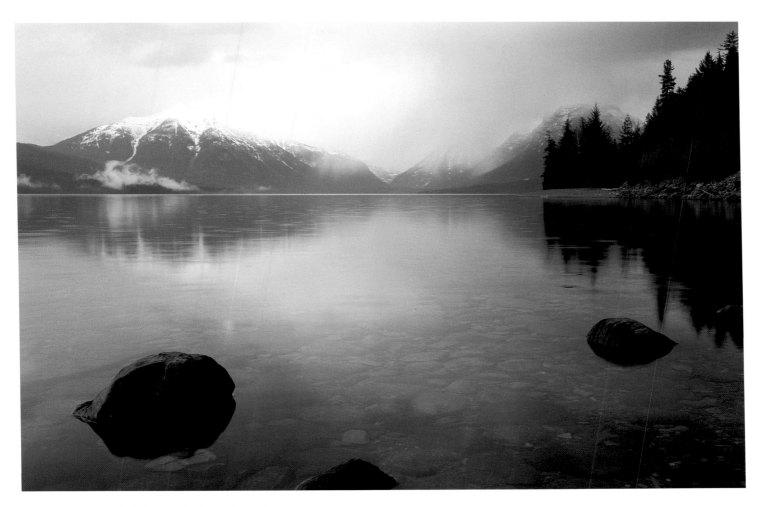

Above: A stormy nightfall view of Lake McDonald from Apgar. KERRY T. NICKOU

Facing page: Cross-country skiing at Many Glacier. KERRY T. NICKOU

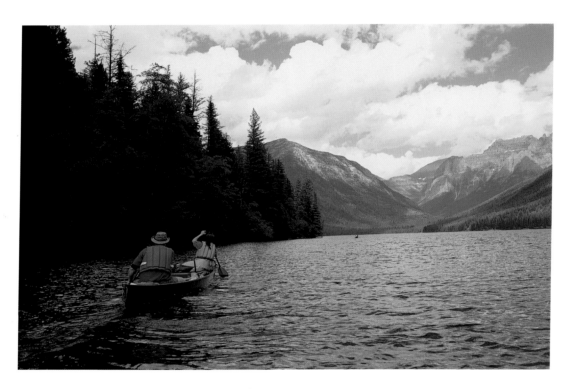

Above: One of many ways to enjoy Bowman Lake. JOHN REDDY

Right: Boulder Peak. JOHN REDDY

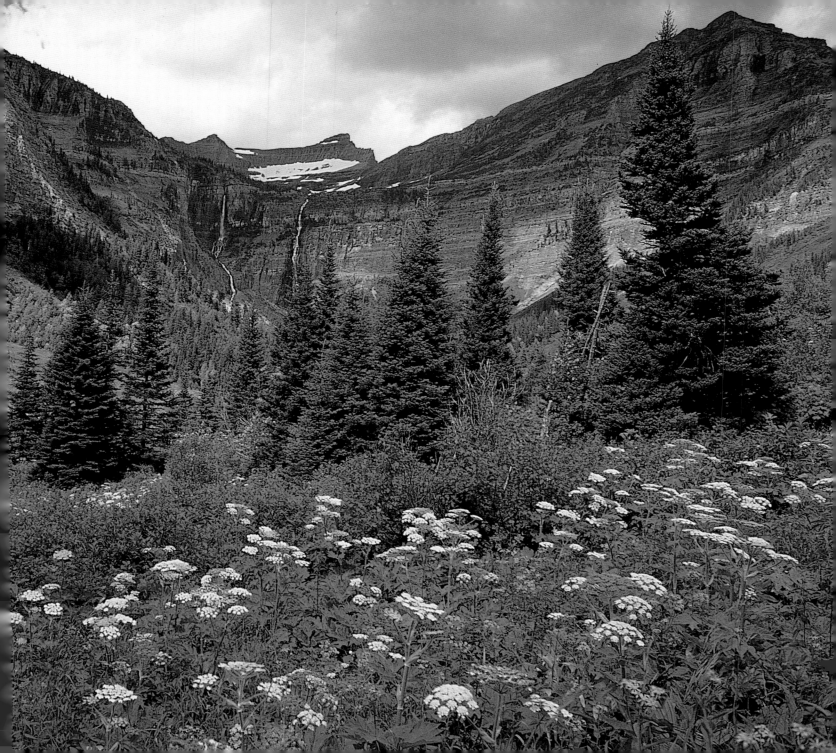

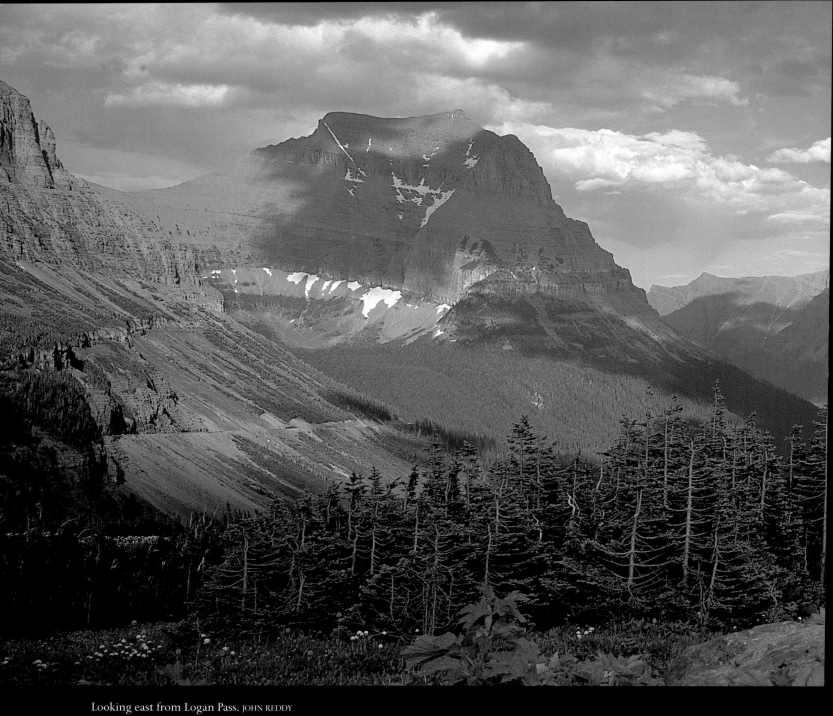

Looking east from Logan Pass. JOHN REDDY

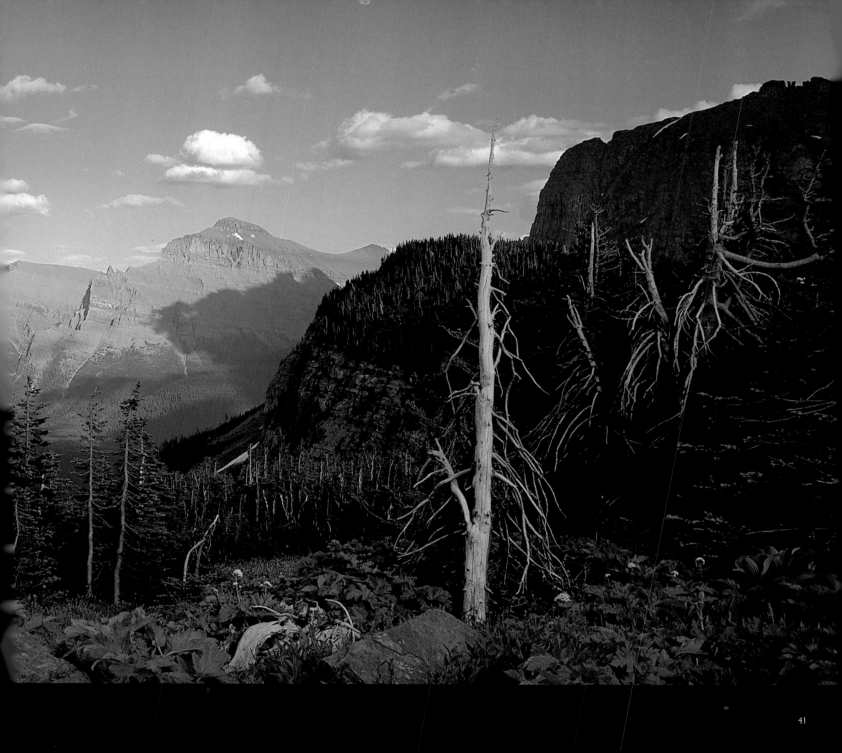

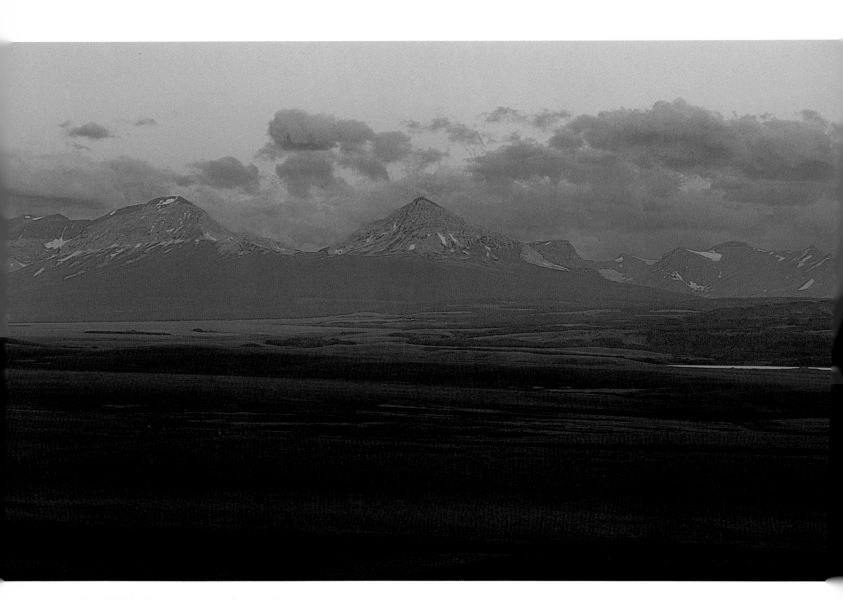

Above: Divide Mountain greets the morning. KERRY T. NICKOU

Facing page: Fireweed, an early post-fire colonizer, near Apgar. KERRY T. NICKOU

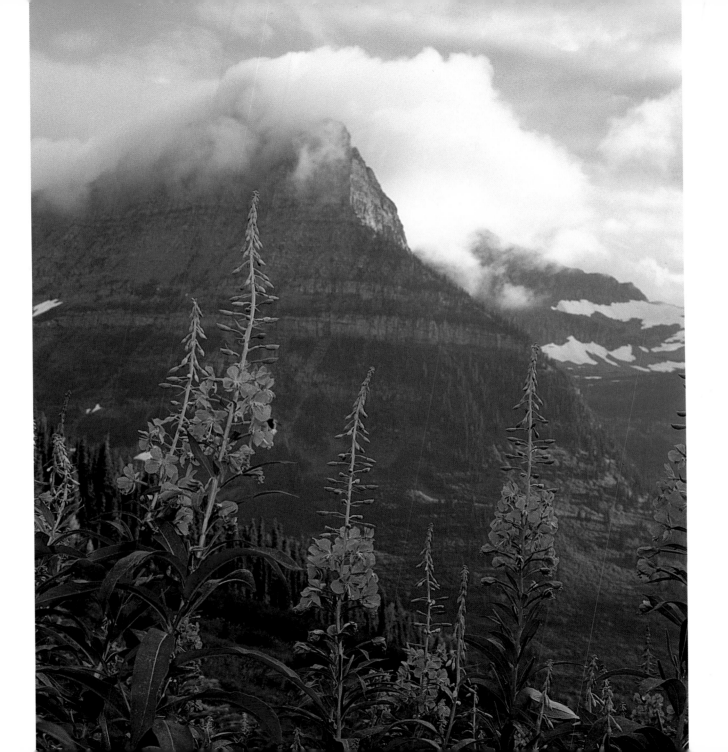

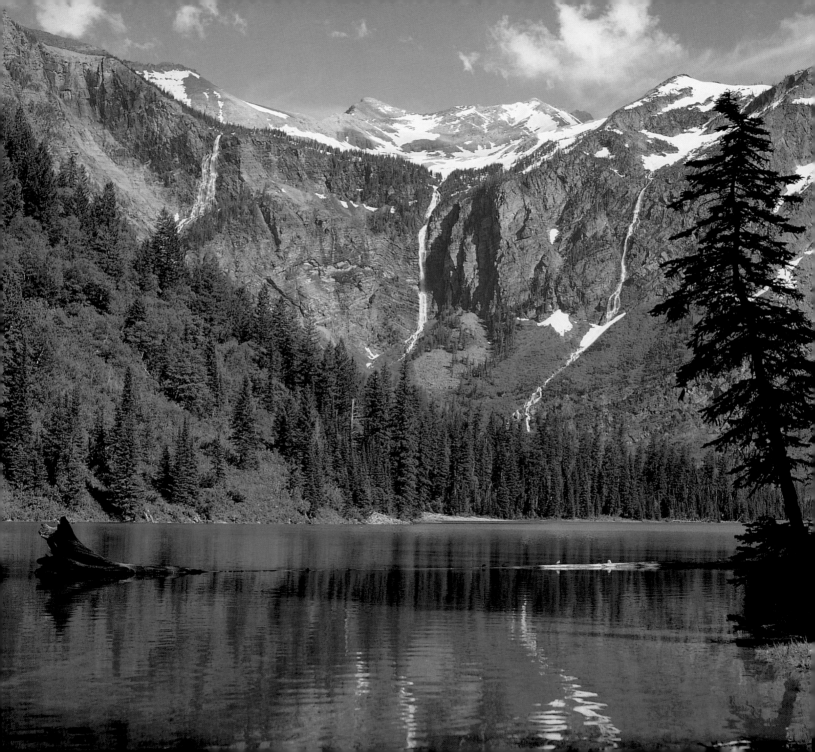

Left: Black bear cubs are
excellent climbers.
KERRY T. NICKOU

Facing page: Avalanche
Lake near West Glacier.
KERRY T. NICKOU

45

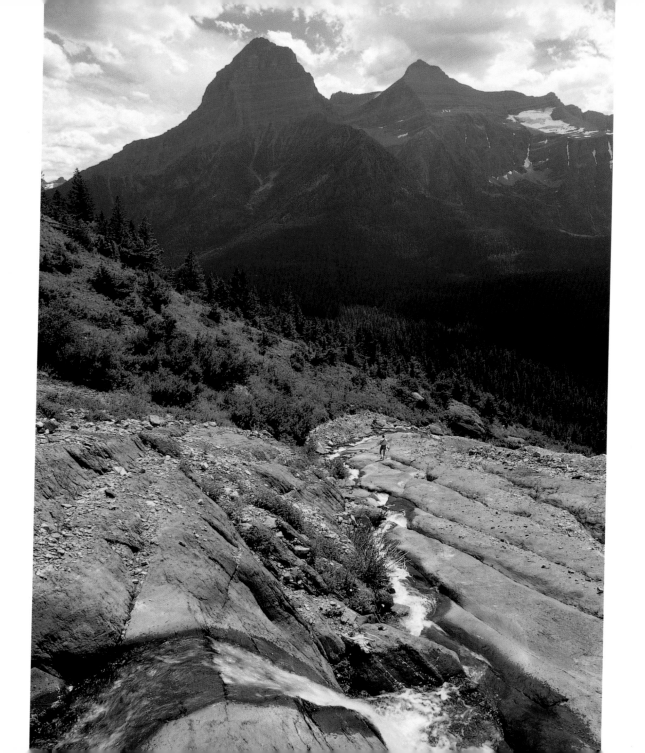

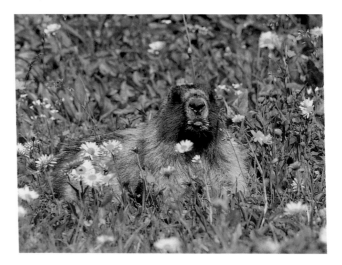

Right: The hoary marmot gets its name from the frost-coated appearance of its fur. KERRY T. NICKOU

Below: Does a traveling party of grizzly bears wear people bells? KERRY T. NICKOU

Facing page: En route to Kinnerly and Kintla peaks. JOHN REDDY

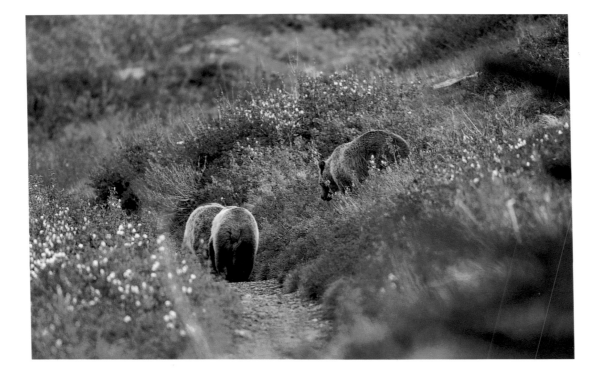

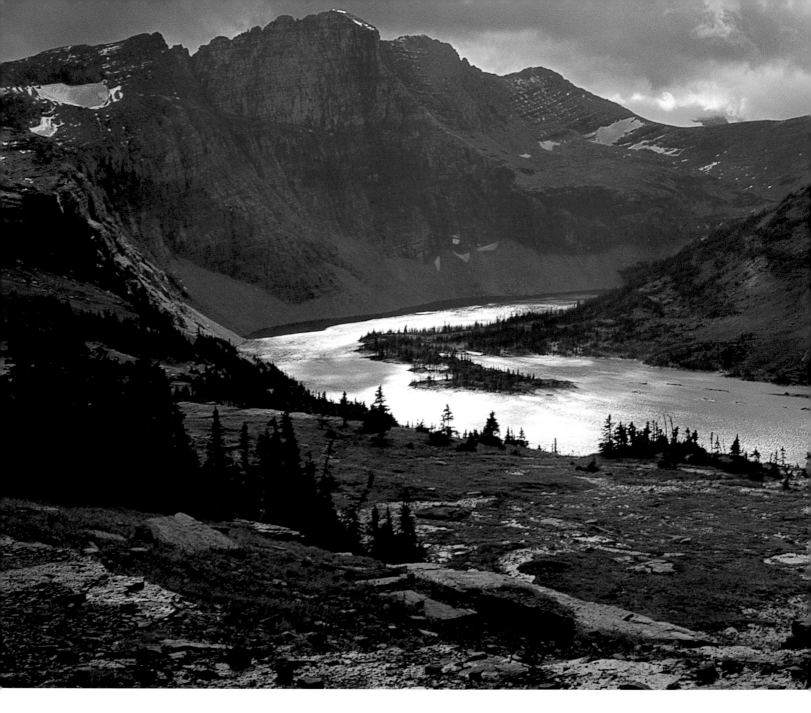

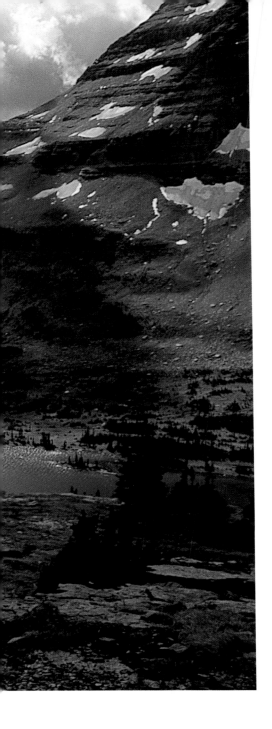

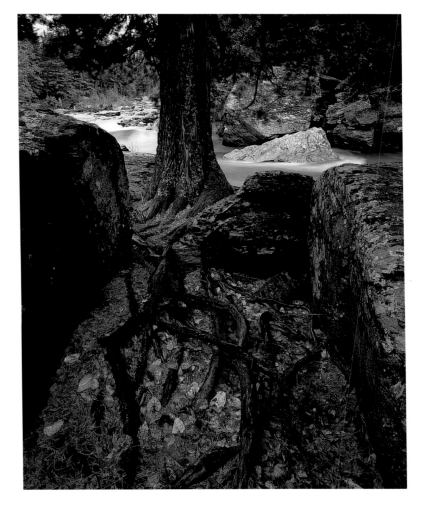

Above: Along McDonald Creek. JOHN REDDY

Left: Hidden Lake. JOHN REDDY

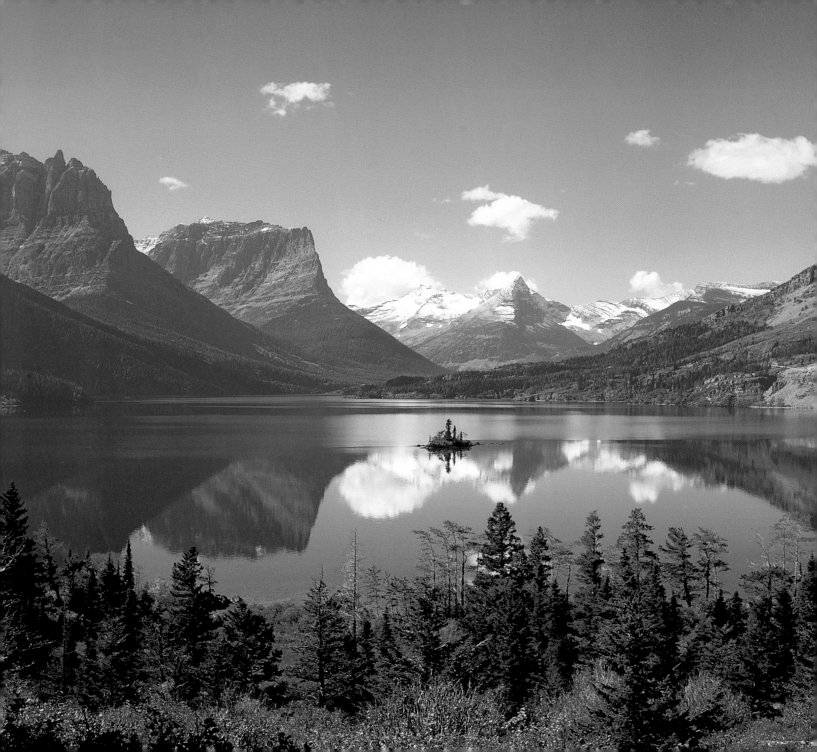

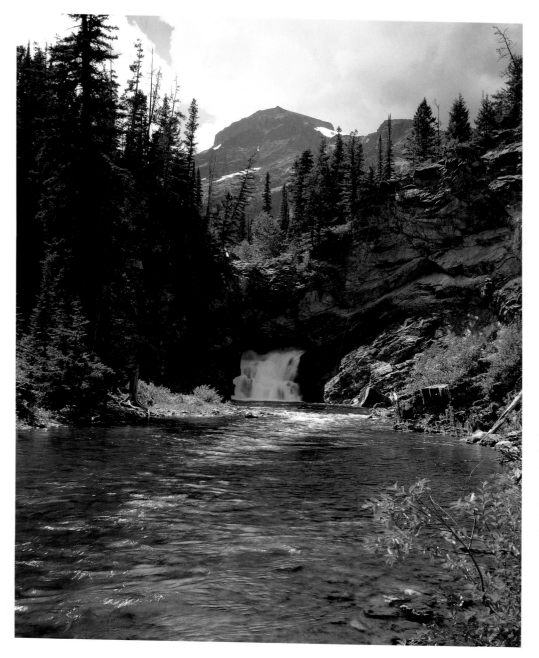

Left: Running Eagle Falls below Two Medicine. JOHN REDDY

Facing page: High noon at St. Mary Lake. KERRY T. NICKOU

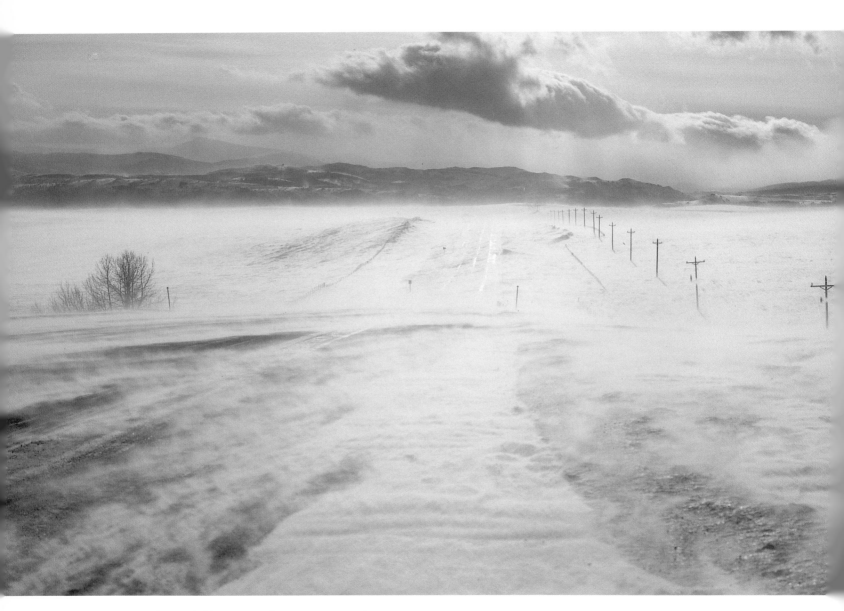

Above: A ground blizzard obliterates Highway 2 near East Glacier. JOHN REDDY

Facing page: Avalanche Creek. KERRY T. NICKOU

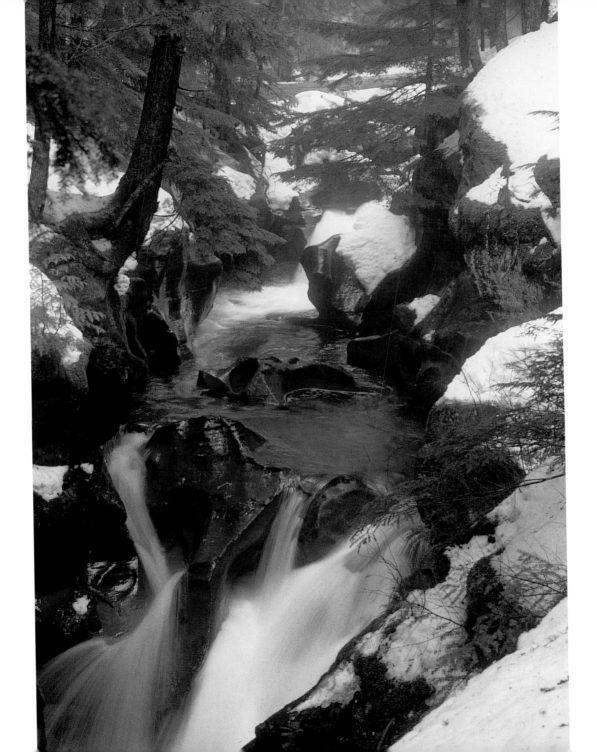

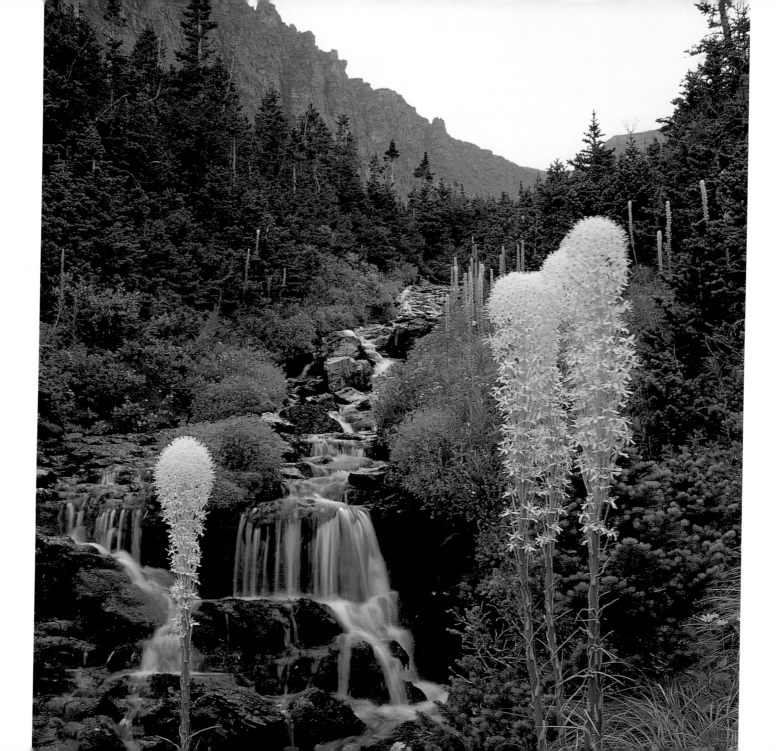

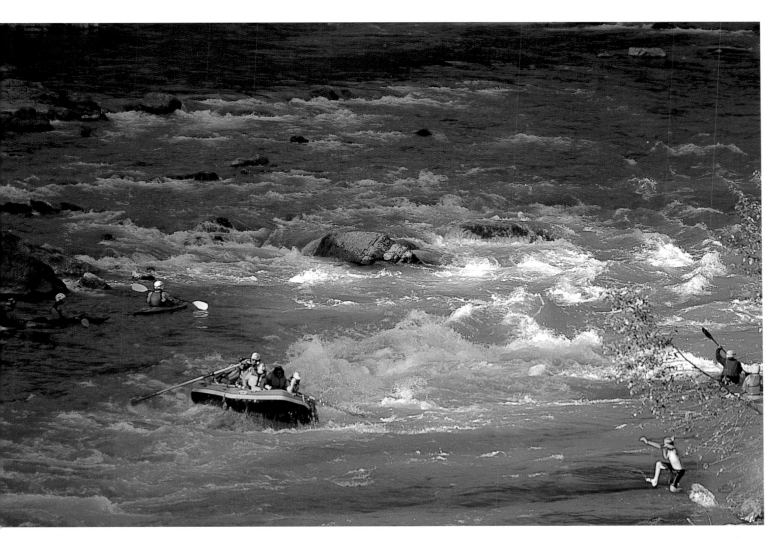

Above: Enjoying whitewater on the Middle Fork of the Flathead River. KERRY T. NICKOU

Facing page: Beargrass provides springtime flower snacks for many creatures, and leafy winter forage for mountain goats. KERRY T. NICKOU

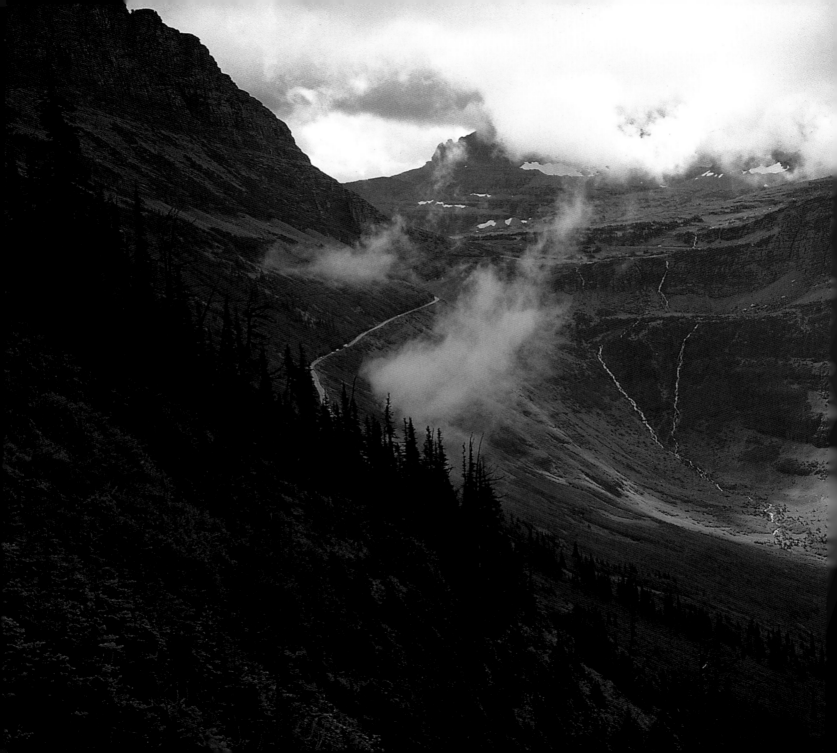

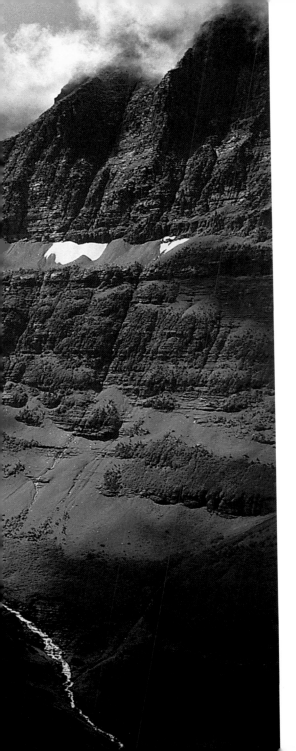

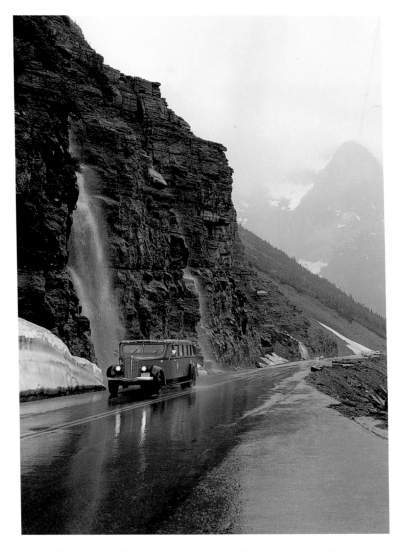

Above: The park's red buses are a beloved tradition for touring Going-to-the-Sun Road. KERRY T. NICKOU

Left: Clouds make their way over Logan Pass, in this view from the Highline Trail. JOHN REDDY

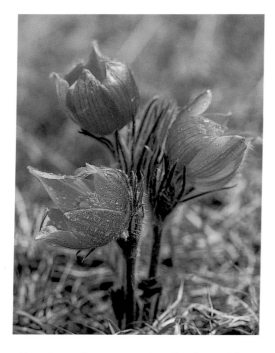

Above: Pasqueflowers range in color from white to blue, and blossom early to late in the spring. KERRY T. NICKOU

Right: Rising Wolf Mountain is named for Hugh Monroe, a 19th century mountain man who married into the Blackfeet Nation. KERRY T. NICKOU

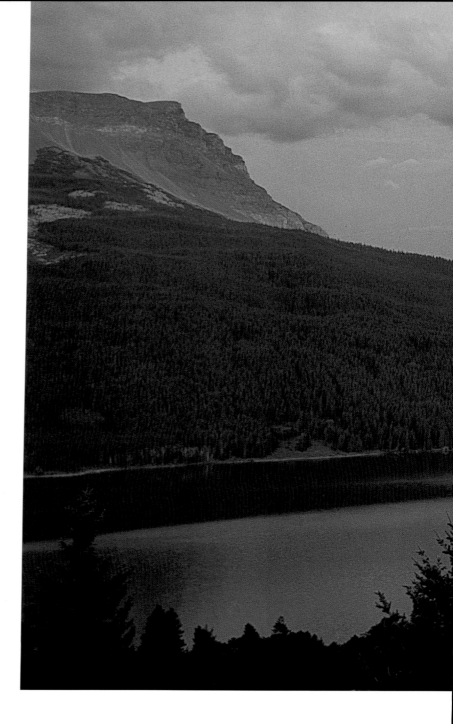

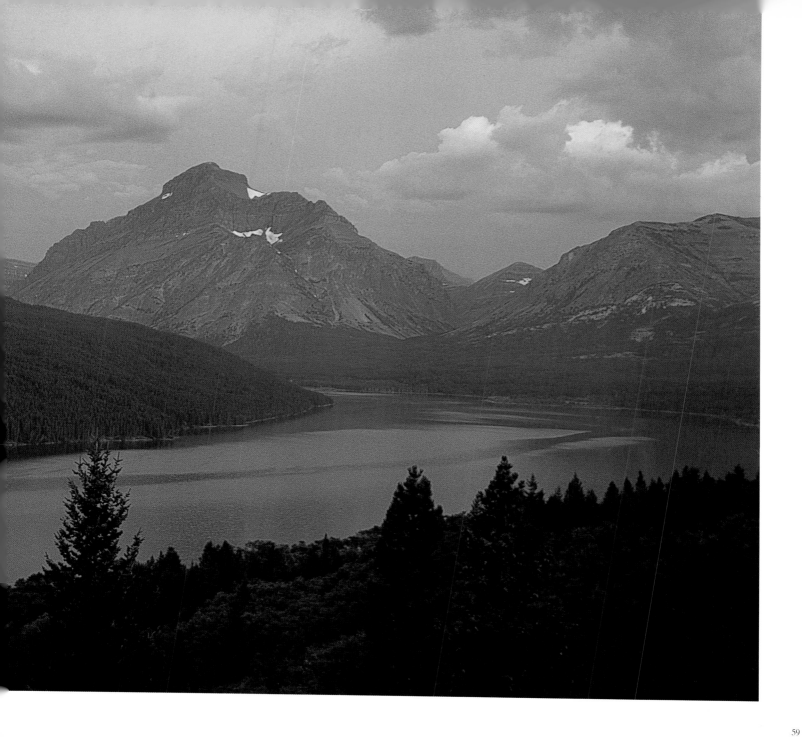

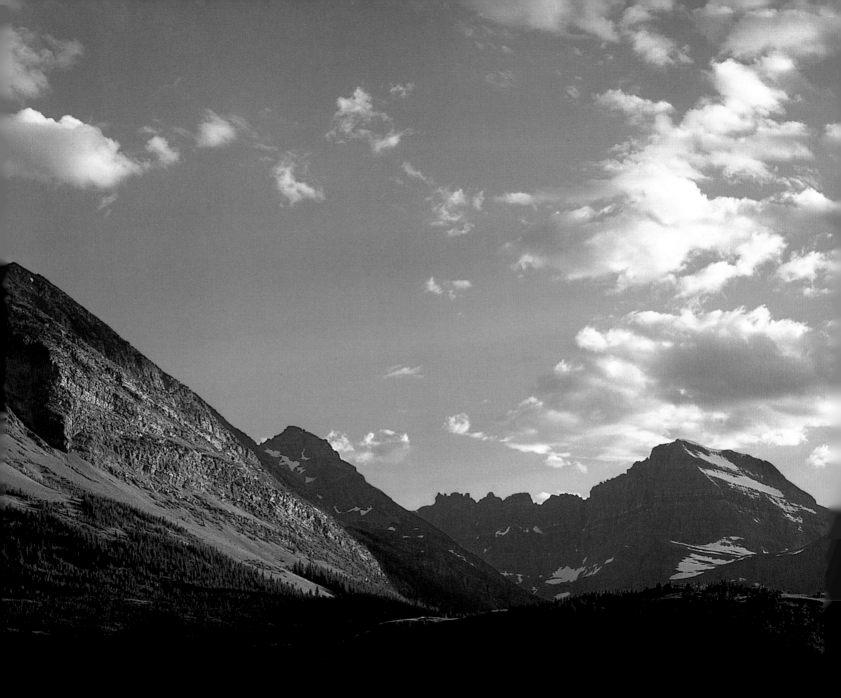

Grinnell Peak, at left, is named for George Bird Grinnell,
who first suggested creating the park. JOHN REDDY

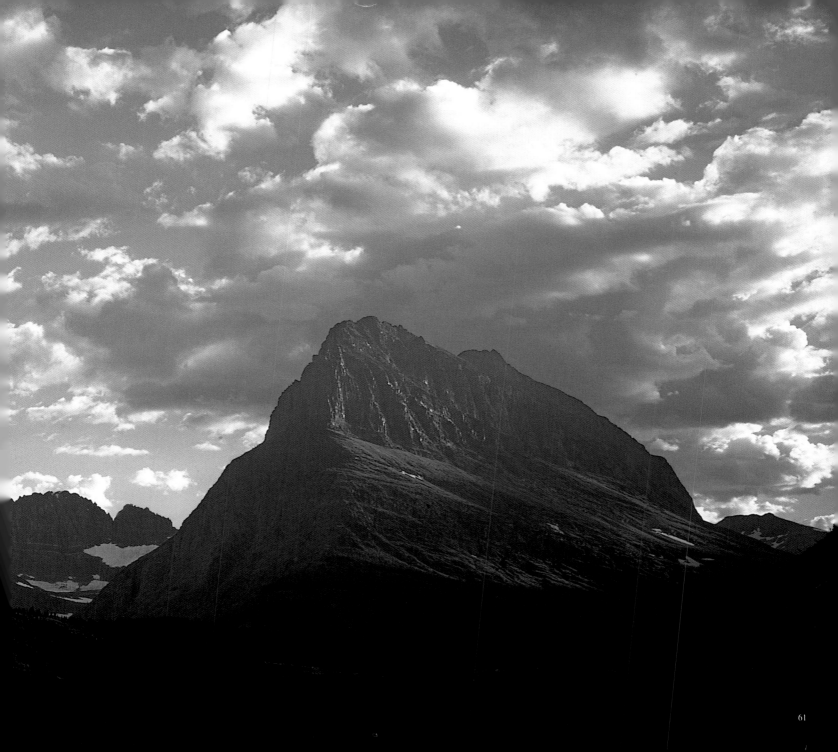

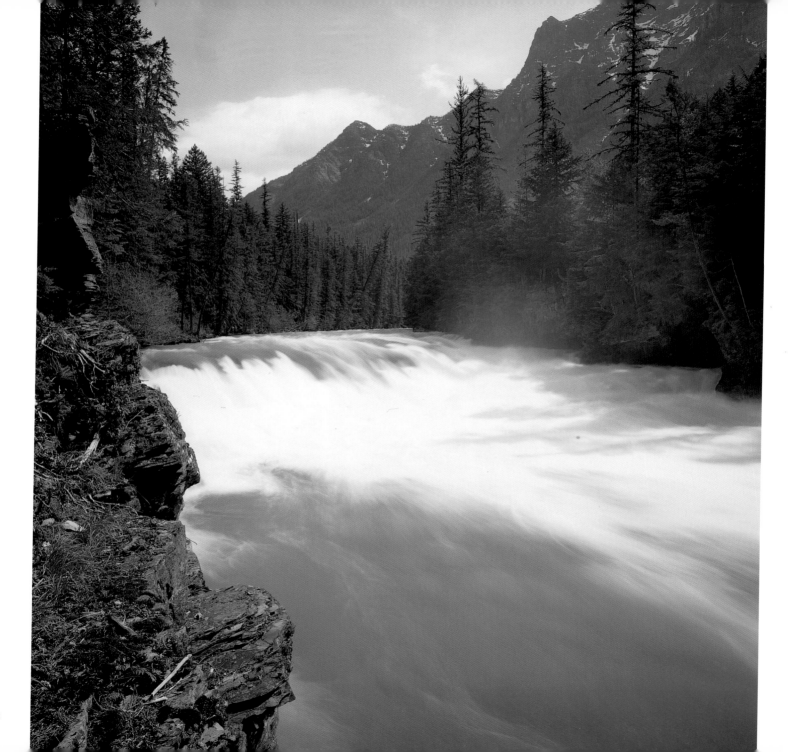

Right: The root below camas blossoms served native peoples as a potato-like food. JOHN REDDY

Below: On the Blackfeet Indian Reservation near East Glacier. JOHN REDDY

Facing page: Sacred Dancing Cascade on McDonald Creek. JOHN REDDY

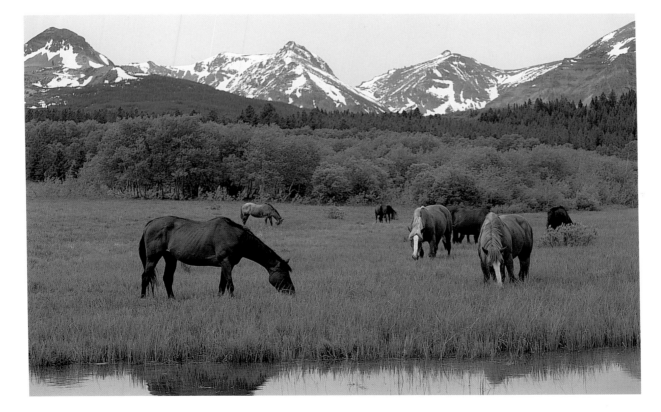

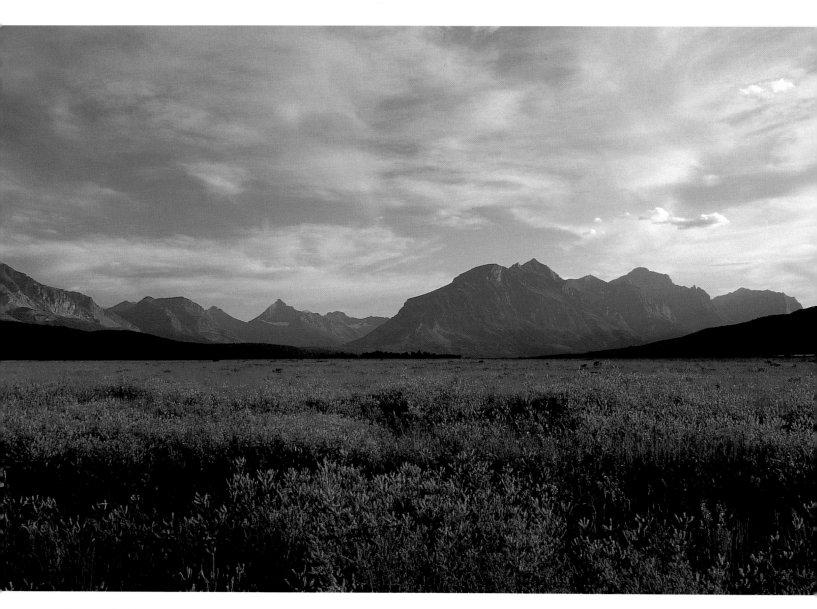

Near the St. Mary entrance. KERRY T. NICKOU

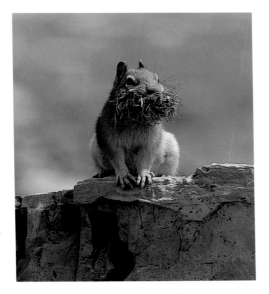

Left: Golden-mantled ground squirrels collect food for their winter dens.
KERRY T. NICKOU

Below: Red birch trees. JOHN REDDY

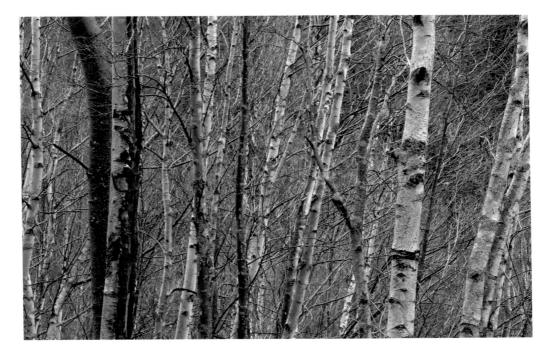

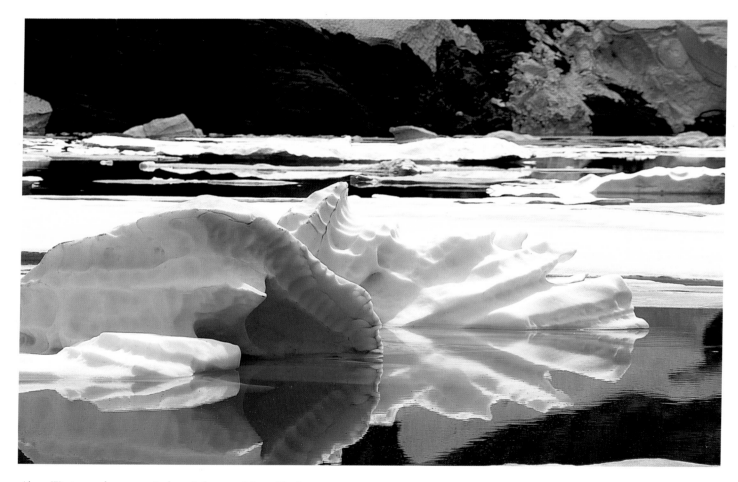

Above: Winter sculpture on Iceberg Lake near Many Glacier. KERRY T. NICKOU

Facing page: Sinopah Mountain rises above Two Medicine Lake. KERRY T. NICKOU

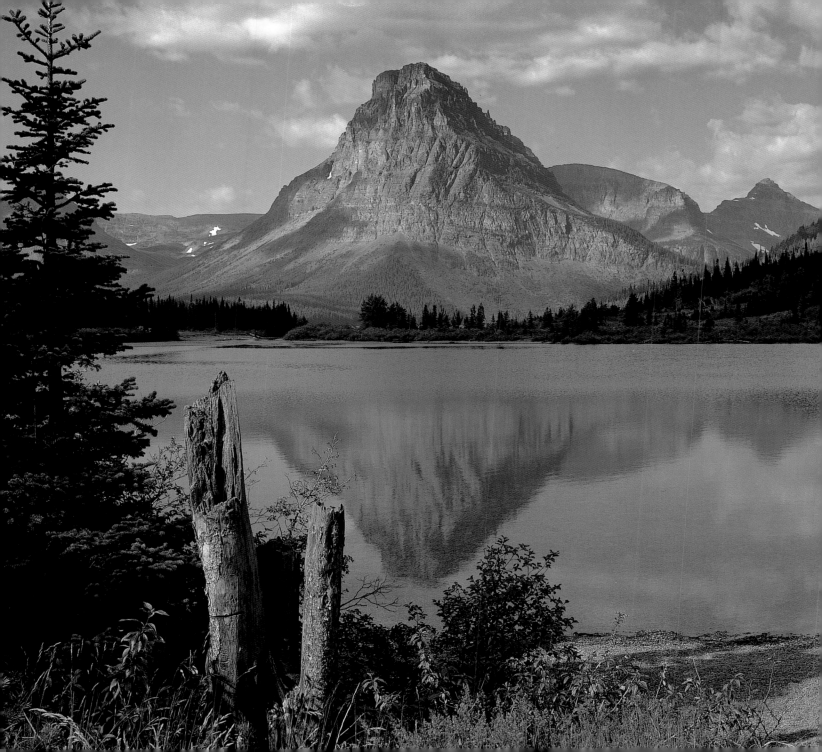

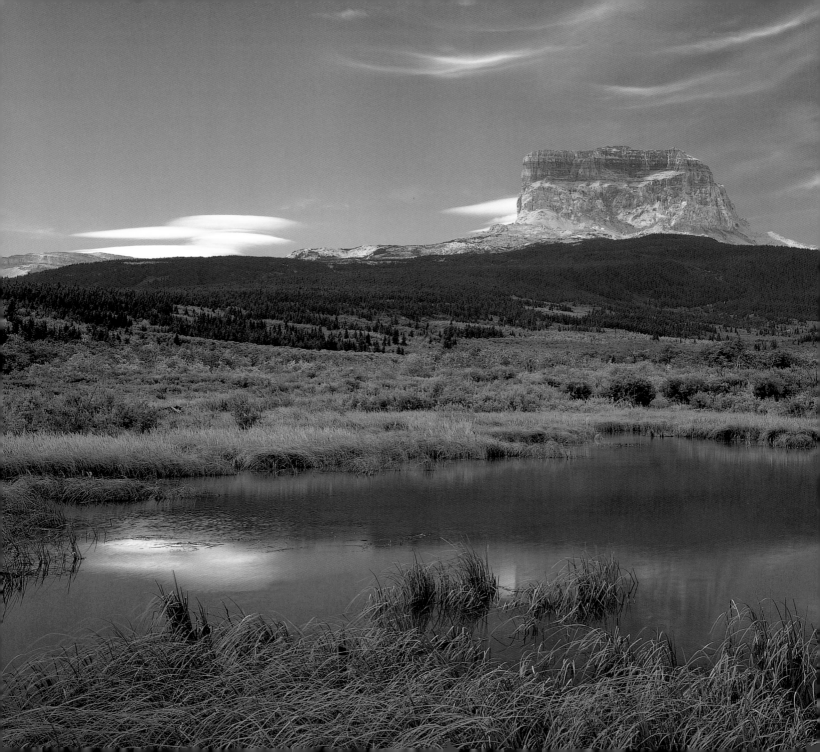

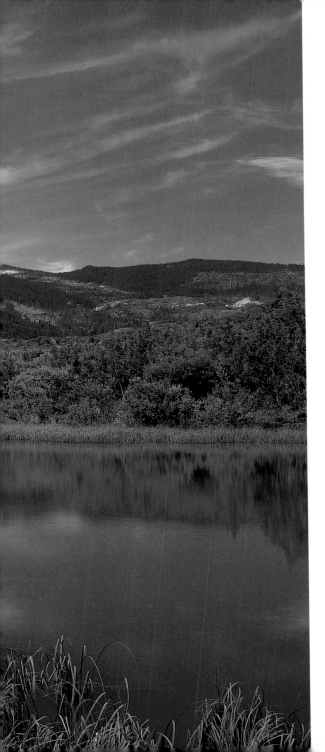

Above: Nature's garden features the purple of lupine and the pink of paintbrush.
JOHN REDDY

Left: A perfect summer day at Chief Mountain. JOHN REDDY

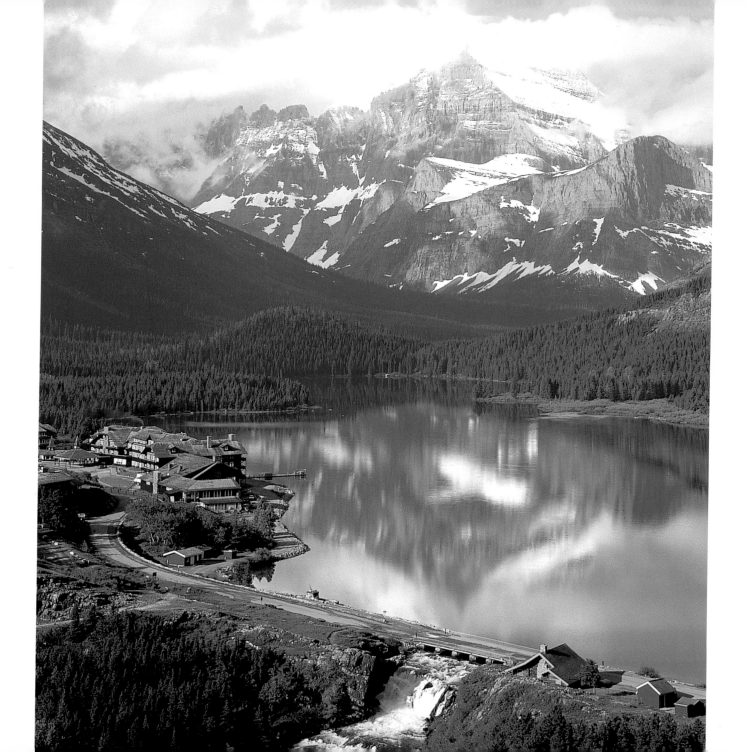

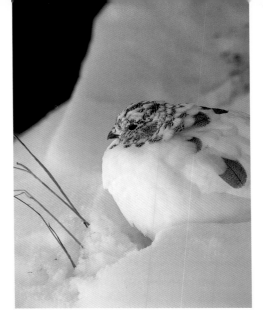

Left: A ptarmigan at Logan Pass, changing from summer camouflage to winter garb. KERRY T. NICKOU

Below: Redrock Lake near Many Glacier. KERRY T. NICKOU

Facing page: Swiftcurrent Lake and Many Glacier Hotel. KERRY T. NICKOU

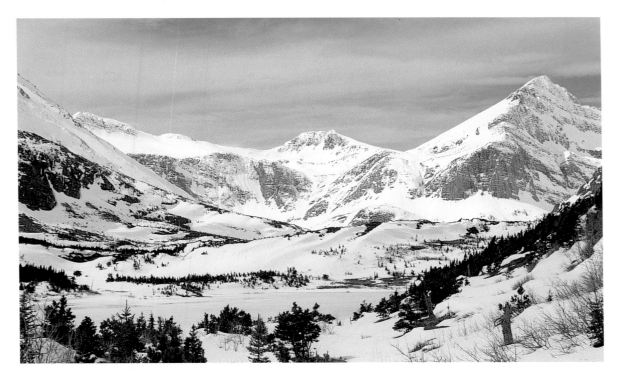

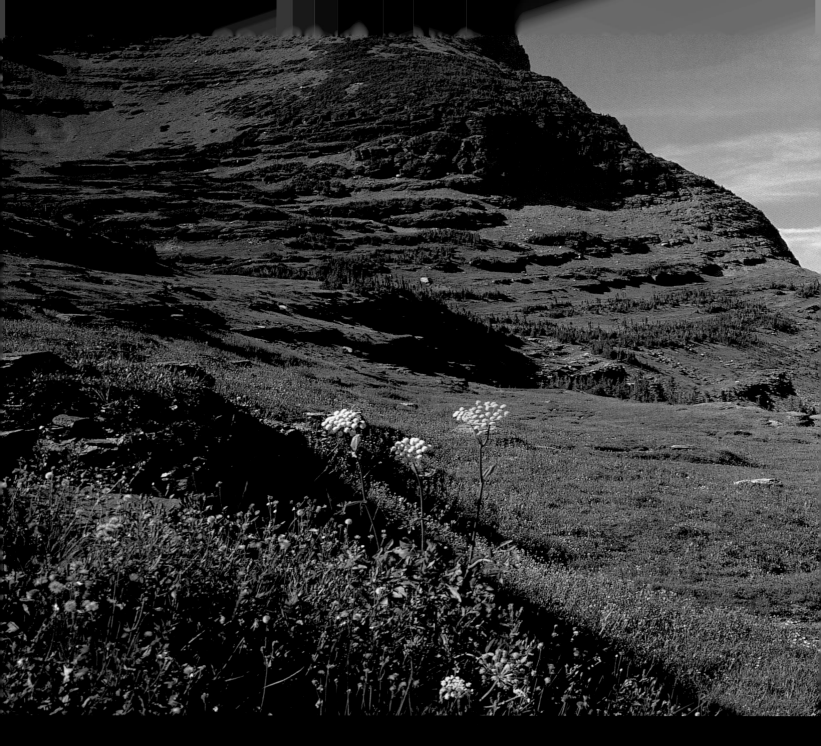

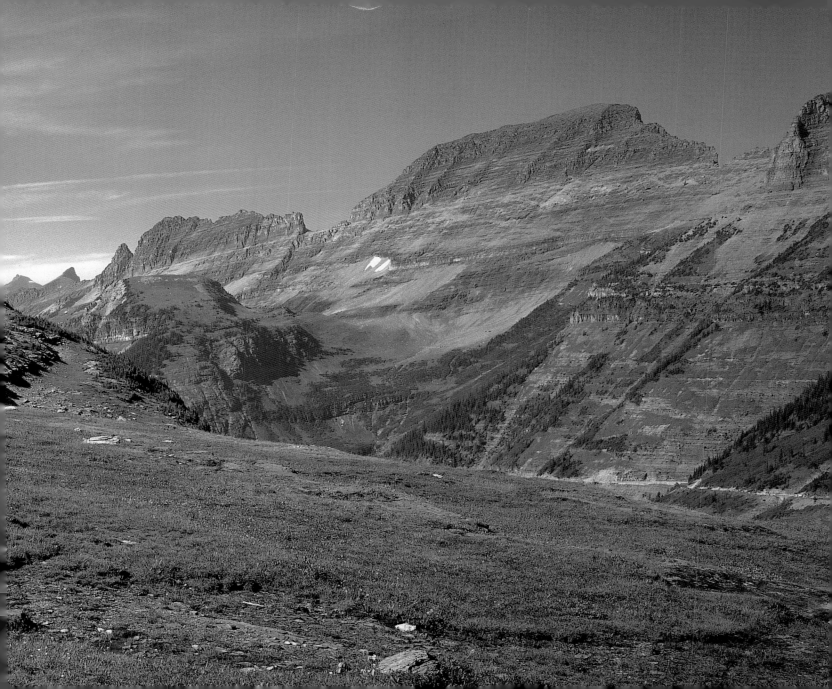

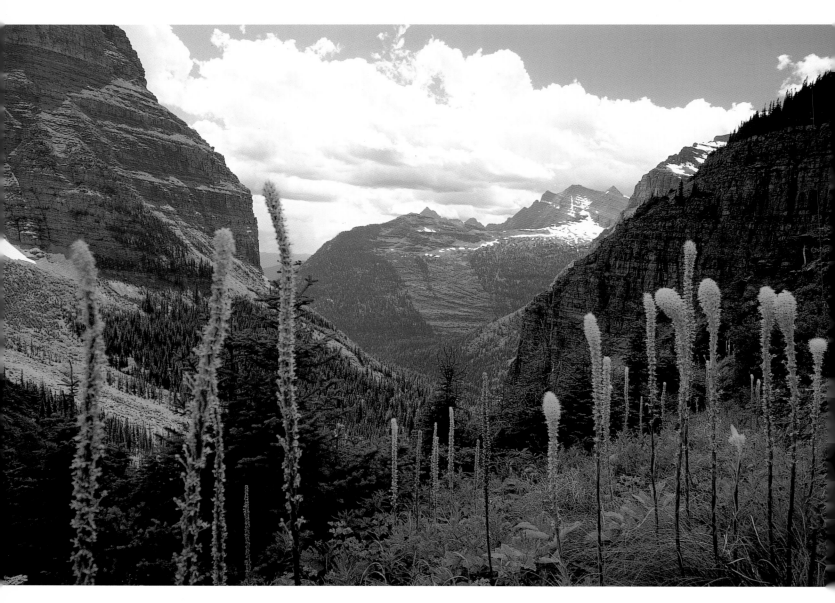

Above: Thunderbird Mountain. JOHN REDDY

Facing page: Reflections in McDonald Creek. JOHN REDDY

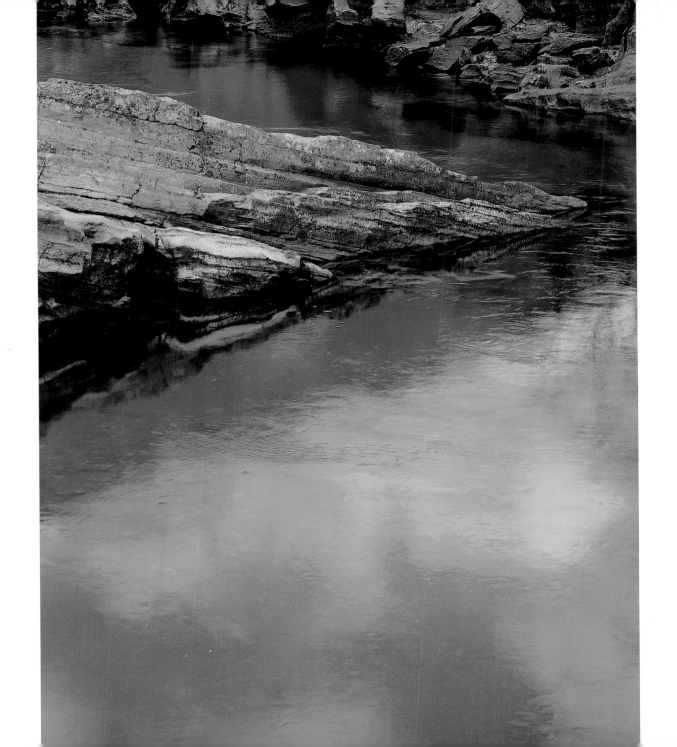

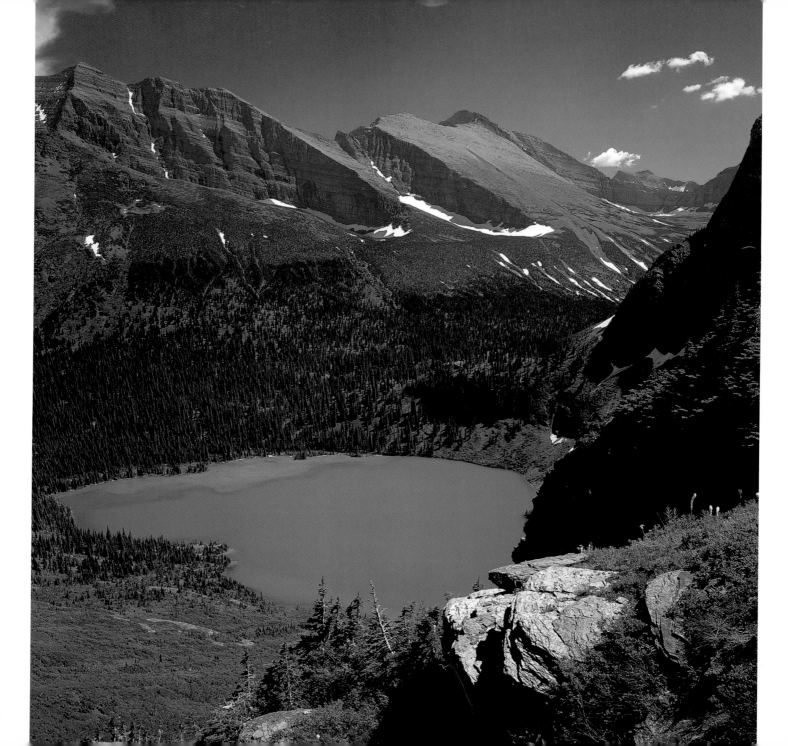

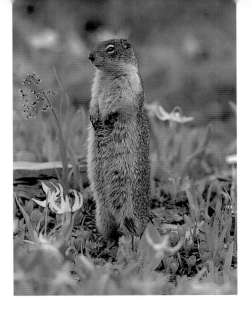

Left: A Columbian ground squirrel goes on alert. KERRY T. NICKOU

Below: White-tailed deer with antlers in velvet. KERRY T. NICKOU

Facing page: Grinnell Lake, named for George Bird Grinnell. JOHN REDDY

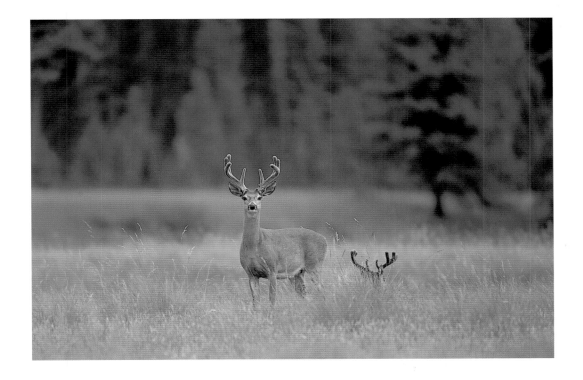

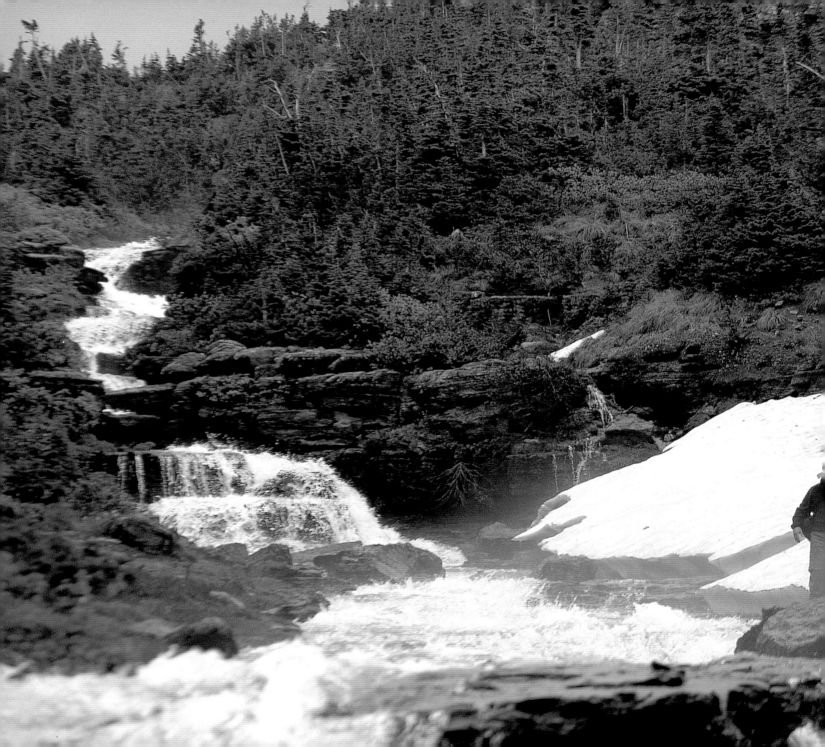

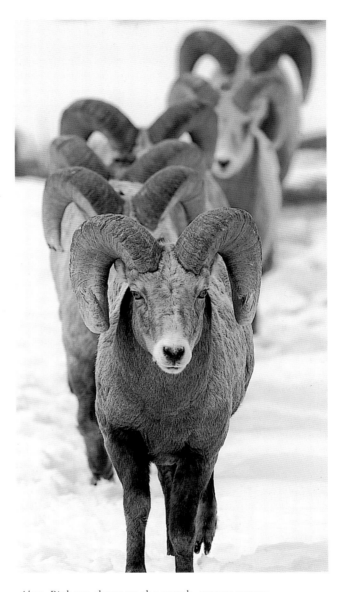

Above: Bighorn sheep on the march. KERRY T. NICKOU

Left: Hiking at Lunch Creek early in the season. KERRY T. NICKOU

John Reddy's photography has illustrated regional and national periodicals including *Smithsonian* and *Montana Magazine,* and books including *Glacier Wild & Beautiful,* and the Compass American Guide, *Montana.* His primary tool for landscape photography is a 4x5 field camera.

He lives in Helena, Montana, with his wife Judy and teenage son Joe.

Kerry T. Nickou lives just outside of Glacier National Park in Browning, Montana, where he is a family nurse practitioner for the Indian Health Service on the Blackfeet Indian Reservation.

His images—photographed only in the wild and never at game farms—have appeared in *Montana Magazine, Montana Outdoors,* and *Bugle,* and in the book *Weekender: Montana Road Trips.* He also produces and sells fine art prints of his work through galleries.

He and his wife Deborah are the parents of sons Thomas and Donald, who are in college.